New York City

YESTERDAY AND TODAY

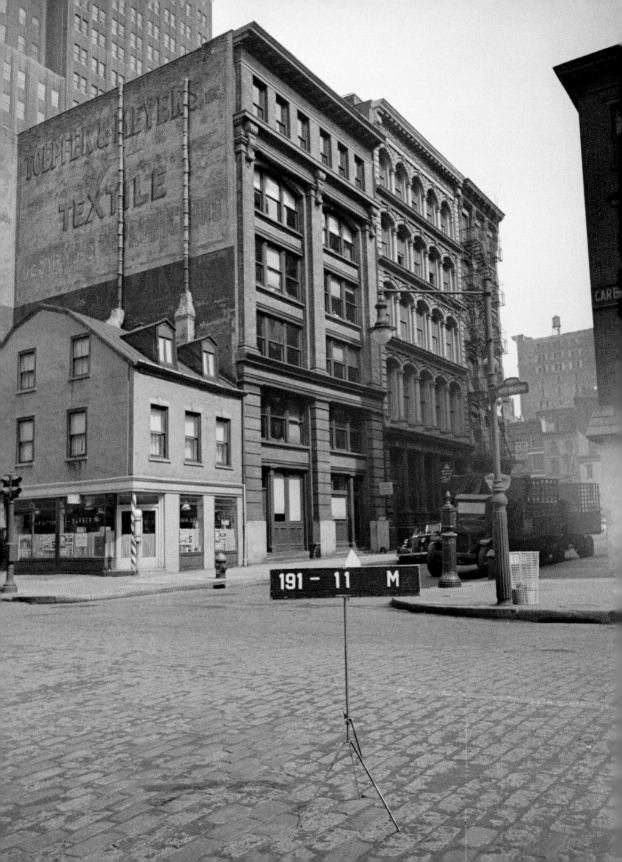

New York City

YESTERDAY AND TODAY

Exploring the City's Tax Photographs

Jamie McDonald

Globe
Pequot

ESSEX, CONNECTICUT

An imprint of Globe Pequot , the trade division of
The Rowman & Littlefield Publishing Group, Inc.
4501 Forbes Blvd., Ste. 200
Lanham, MD 20706
www.rowman.com

Distributed by NATIONAL BOOK NETWORK

Tax photography courtesy of the Municipal Archives, City of New York
New photography by Jamie McDonald and Heather Hacker unless otherwise noted.

British Library Cataloguing in Publication Information available

Library of Congress Cataloging-in-Publication Data

Names: McDonald, Jamie, 1970- author.
Title: New York City yesterday and today : exploring the city's tax photographs / Jamie
 McDonald.
Description: Essex, Connecticut : Globe Pequot, [2023] | "Old photographs courtesy of
 the City of New York. New photography by Jamie McDonald"–T.p. verso. | Summary:
 "Features the little-known tax assessment photographs from The City of New York's Hall
 of Records and how those areas look today"– Provided by publisher.
Identifiers: LCCN 2022028409 (print) | LCCN 2022028410 (ebook) | ISBN 9781493052110
 (hardback ; acid-free paper) | ISBN 9781493052127 (epub)
Subjects: LCSH: New York (N.Y.)–History–Pictorial works. | Historic buildings–New York
 (State)–New York–Pictorial works. | New York (N.Y.)–Buildings, structures, etc –Pictorial
 works. | Repeat photography–New York (State)–New York.
Classification: LCC F128.37 .M16 2023 (print) | LCC F128.37 (ebook) | DDC
 974.7/10222–dc23/eng/20220706
LC record available at https://lccn.loc.gov/2022028409
LC ebook record available at https://lccn.loc.gov/2022028410

∞™ The paper used in this publication meets the minimum requirements of American
National Standard for Information Sciences–Permanence of Paper for Printed Library
Materials, ANSI/NISO Z39.48-1992

Dedicated to my neighbors Ed and Gayle
who enjoyed watching the process of this book
coming together as much as I did writing it.

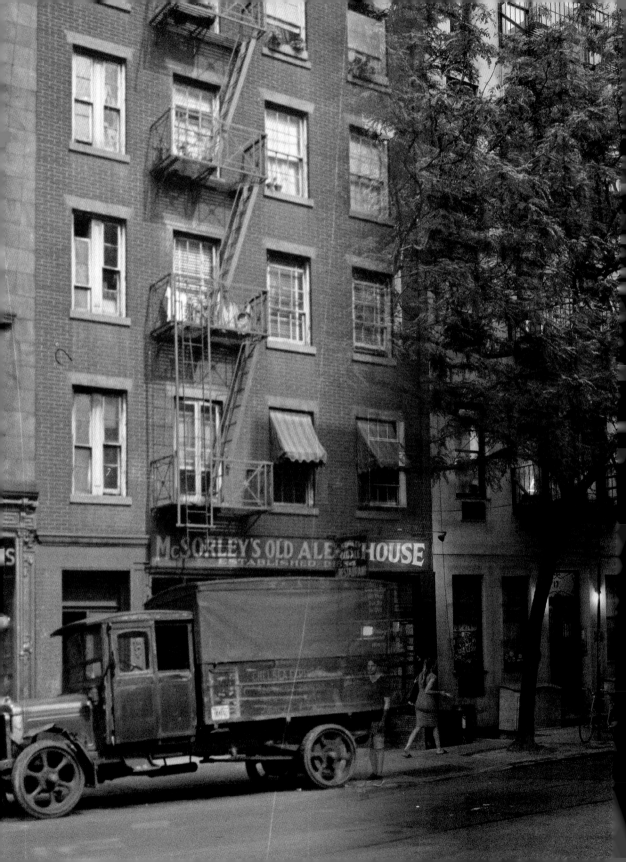

Contents

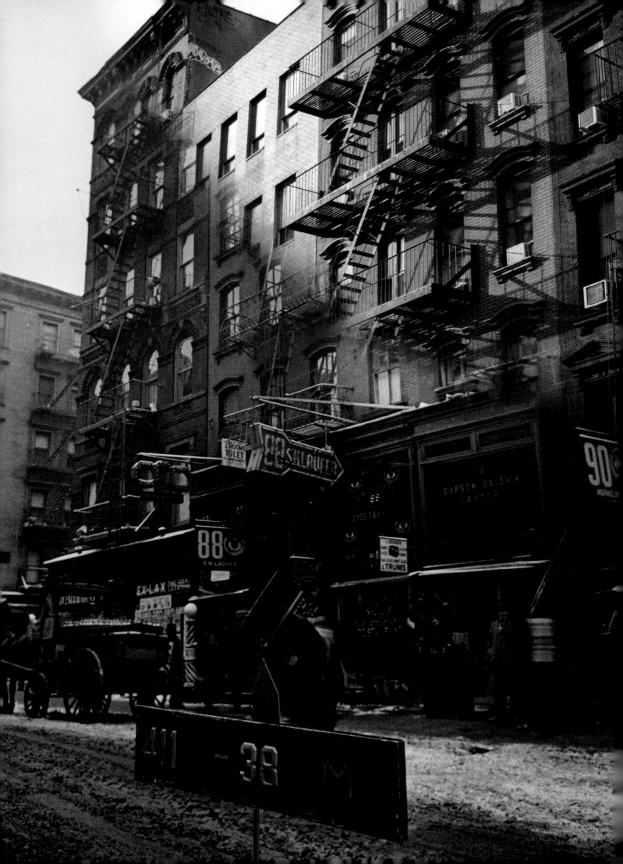

Acknowledgments

First and foremost, I cannot thank Heather Hacker enough for her meticulous work creating the then-and-now images for this book. Heather spent an incredible amount of time carefully stitching these photos together, creating a visual effect even better than we had envisioned. For more of her wonderful, creative work, check out her website at Ripearts.com.

Just as important to this project were the good people at New York City's Department of Information Services. The book would not exist without their help and guidance. Commissioner Pauline Toole, assistant commissioner Kenneth Cobb, project manager Kelli O'Toole, and archivists Quinn Bolewicki and Matt Minor all provided essential help tracking down errant addresses and mislabeled photos and compiling the best ideas and photographs. Most importantly, they started me off with a road map of their favorite 800+ tax photographs in the entire collection.

Thanks to computer scientist and genealogy enthusiast Stephen P. Morse, who put together an invaluable website that streamlines the process of tracking down tax photographs. (More on that later in the book.)

Also, Danielle Ridgway for your eagle-eye copyediting which helped free me to be more creative with the style and content of the book.

Lastly, thank you to all the viewers and fans of my PBS television series, *New York Originals*. I enjoy your updates about visiting those great mom-and-pop businesses and appreciate your keeping up with my projects. Now, onto this one!

Scale 1 Inch = 100 Ft. **PLOT DIAGRAM** Indicate North | **BUILDING DIAGRAM** 1 Di

Scale 1 Inch = 100 Ft. **PLOT DIAGRAM** Indicate North | **BUILDING DIAGRAM** 1 Div

5205 -215 04

EASEMENTS—Date Acquired_____In Whose Favor?_____

Character_____

LAND VALUE CALCULATION	%	19 38	%	19	%	19	%	19	%	19	%	19
UNIT VALUE PER FRONT FT.		70										
FRONTAGE X UNIT VALUE		88,400										
Deduction for: SUB-STANDARD DEPTH	10											
Specify Other												
Irregular Shape	4	8,400										
Sub-Total		80,000										
Addition for: CORNER INFLUENCE												
Specify Other												
PLOTTAGE												
TOTAL VALUE		80,000										

CONDITION OF BUILDING

STRUCTURE IS	DATE
An Appropriate Improvement	
An Over Improvement	
An Under Improvement Obsolete	
PHYSICAL CONDITION	DATE

RECORD OF ASSESSMENTS | **EXEMPTION** | **WRITS**

YEAR	TENTATIVE & FINAL VALUE Land	Improvements Add.	Total	Assessor	Bldg. Factor Sq. Ft. Cu. Ft.	PURPOSE: Land	Total	VALUE CLAIMED	DISPOSITION	DATE	GRANTOR
19 31	EXEMPT			DB		80,000	95,000				
19 32	EXEMPT			DB		80,000	95,000				
19 33	EXEMPT			DB		80,000	95,000				
19 34	EXEMPT			JP		80,000	95,000				
19 35	80,000	15,000	95,000	MR							
19 36	80,000	30,000	110,000	MR							
19 37	80,000	30,000	110,000	MR						DATE	MO
19 39	80,000	30,000	110,000	MR							
19 40	"	"	"	"							
19 41	"	"	"	"							
19 42	5,000	6,100	10,100	"							
19 43	5,000	6,500	11,500	"							
19 44	"	"	"								
19											
19											

Introduction

What you are about to view are photographic treasures, born out of a practical need from a local governmental bureaucracy—the tax department for the City of New York, no less. These images were never meant to be as intriguing, as intimate, or as revealing as they are to modern eyes. Mostly by accident, they reveal truthful, unvarnished views of a way of life that is now largely forgotten.

The City of New York Tax Photographs, as they're called, were created to help the city assess and collect real estate taxes more efficiently. The project was initially funded by the Works Projects Administration (WPA) during the Great Depression.

The tax department's lofty goal was to log and photograph *every* building and lot in the city. Incredibly, for the most part they succeeded, producing over 720,000 files on virtually every piece of real estate in the city. The process included giving each individual building and/or lot its own 8- by 14-inch paper property card file that contained a 2½- by 3-inch photo of the property. The files were organized by borough, block, and lot number. Information on the cards included ownership, date of construction, value, mortgages, plot diagram, and anything else useful for assessing taxes. For most of us except, say, real estate speculators or government workers, the property cards make for rather dull reading. However, it is the photographs that are so fascinating today. The project proved successful enough that reshoots were done

yet again in the 1980s, resulting in hundreds of thousands of additional photographs, this time in high-quality color.

To create these images, teams of photographers and clerks canvassed all five New York City boroughs, shooting the tax photographs mostly between 1930 and 1940. By the tail end of 1941, work had mostly stopped due to the looming shadow of World War II. Work picked up again at war's end with reshoots being taken from 1946 to 1951. At one point, close to 1,000 employees worked on the project, mostly auditors and bookkeepers. Only 32 photographers shot the photographs.

Unfortunately, little is known about the workers who participated on the project. Recently though, a tantalizing clue has emerged. A scrap of paper was found in a film canister with names scribbled on it: Munday, Hackman, Pat McCullagh, Evans, Chambers, Garnes, Dummett, Suffal, Gordan, and Cenzar. Hopefully with this publication, someone will connect at least one of these names with the photographers.

From notes and the photographs themselves, modern-day archivists deduce that the men worked in pairs of photographers and clerks. Their equipment included only a municipal city map, a ledger to log information, a 35 mm Leica camera, and a felt signboard with move-able type. The signboards, seen in all the photos, were put in the camera frame to record the building's borough, block, and lot numbers, making the tax photographs immediately recog-nizable from other photo-graphs of the period.

The photographs also reveal the men worked fast and efficiently. Often, they photographed buildings from the same spot with only the signboard and the camera slightly moved. Con-sequently, everyday events were sometimes captured in sequence, like groups of peo-ple walking down the street. In one instance, there's a

house painter captured in a series of photos adjusting and climbing his ladder, seemingly oblivious to the photographers.

The photographers and clerks seemed not to take themselves too seriously. Many photos have a playfulness to them, with the clerks and photographers captured in-frame from time to time, looking relaxed and occasionally clowning around.

Luckily for us, the photo collection includes some interesting outtakes. Loading the cameras sometimes required shooting a couple of frames to start a fresh roll of film. Also, the filing system required the photographers to start each city block with a new roll. Therefore, rolls had to be finished before another block could be started. This allowed the photographers to shoot off the remainder of the roll however they wished. Several of these impromptu images are selfies or images of things they found intriguing—a car accident, a

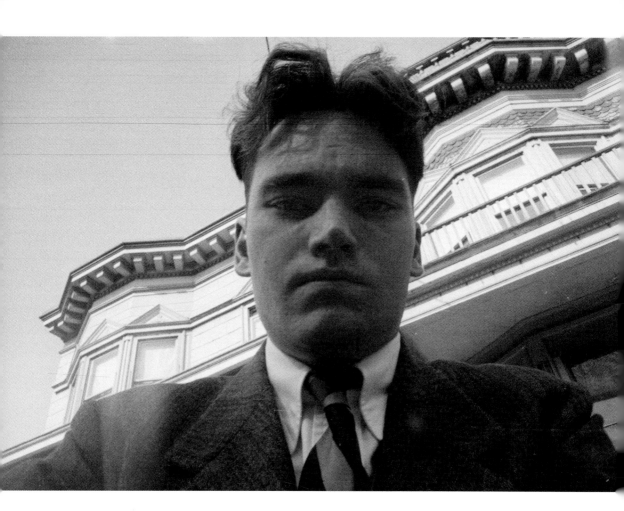

friendly cat, even a set of photos taken at the Staten Island Zoo. One nameless photographer seems more artistic than others, often taking abstract shots of himself and views of the city.

Their creativity and playfulness are apparent in many of the official tax photographs. It is obvious that the photographers and clerks often rounded up curious neighborhood youngsters and posed them. Delighted kids are seen grinning ear-to-ear and mugging for the camera. There's even the occasional vintage photobomb of someone jumping into the frame. None of these images would have been seen today—or the public, for that matter—if it were not for the Municipal Archives of the City of New York. In 1980, they acquired the tax photographs from the New York Department of Finance. Archivists knew immediately the historical importance of these images. However, making them more accessible to the public would be challenging, to say the least. It would take *three decades* to not only get proper funding but

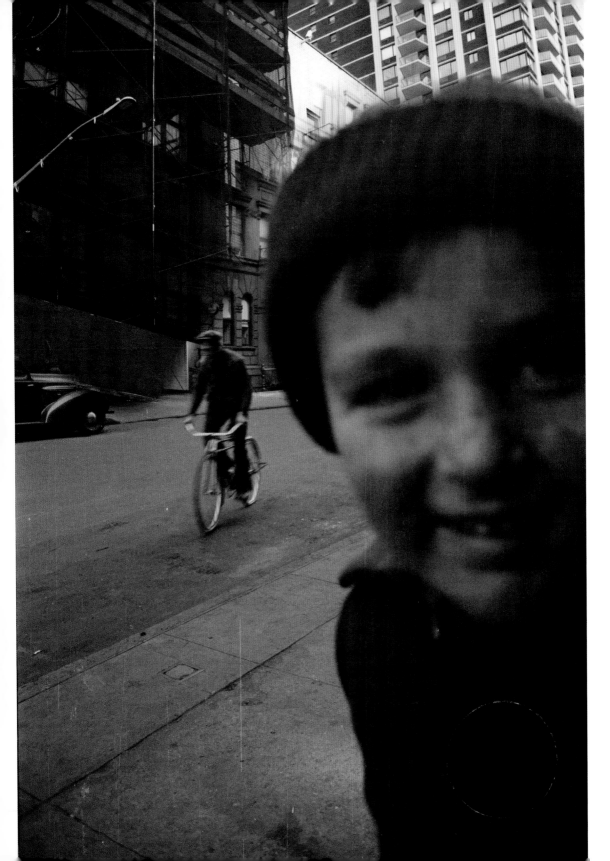

also to sift through all the images to make them accessible to the public.

Initially, the images were stored on over 20,000 original nitrate 35 mm film reels; each contained 38 photos. Adding to the problem was that none of the buildings were referenced by their actual addresses. So, to find a particular building's tax photograph, one would first cross-check the building's address with its designated city block and lot numbers on a city municipal map, then physically go through the corresponding roll manually to find the photograph with the correct block/lot numbers and borough.

But the first step was getting the old nitrate rolls copied onto newer film and to stop the damage from handling and time. The rolls were also duplicated via microfiche film so the public and archivists had a more manageable way of searching the tax photos. However, the microfiche couldn't show the incredible detail the originals revealed, and finding a particular building was still a challenge.

Not until the 2000s did proper funding come through and technology catch up with their needs. After years of planning and research, in 2015 the Municipal Archives again pulled the original rolls out of storage. (They had been preserved in freezers since the 1990s.) The rolls were then shipped to Luna Imaging Lab in California, which was able to digitize and convert each negative into a high-resolution digital image.

Next was the daunting task of reorganizing and correlating all of the block/lot numbers with their numerical addresses and creating a cohesive database. This took the Municipal

Archives almost two years to complete. On November 1, 2018, the collection finally went onto the web for everyone to see. (At the end of this book, I'll walk you through the process so you can do your own online search of the archives.)

Bringing these photographs to light has led to some fascinating outcomes. For instance, many small businesses and building owners today proudly display their building's tax photographs, much to the enjoyment of visitors. Some preservationists have referenced the tax photos when restoring buildings. Many families and amateur genealogists have reconnected with their own history by finding an old family business, home, or whole neighborhood. Recently, one young woman perusing the tax photos found her great-grandmother standing outside the family home.

It is interesting to think: Did these photographers envision their images becoming such a wonderful glimpse into their era? If so, the images could not have been made at a more opportune time. The world was rapidly changing. The Great Depression was slowly coming to a close, and World War II was just around the corner. New York City, as well as the rest of the world, for better or worse, would soon change forever.

You may feel a sense of a loss but also comfort when viewing these images. It is one of the reasons this book is designed this way. Then-and-now photos are put side-by-side; many photographed in the exact spot where the original photographers shot their photos. Other then-and-now images are merged together, helping readers get their bearings but also illustrating the incredible changes throughout the city. For instance, so much of what was photographed is no longer here. Many neighborhoods are figuratively and literally gone, wiped out by city planners, the middle class's mass exodus to the suburbs, or just the inevitable changes of time. For example, the neighborhood known as Little Syria, which is where the World Trade Center Complex sits, has almost nothing to show from its bustling days as an immigrant enclave.

Everyday life depicted in these photographs often seems worlds apart from our own. People out and about are almost always well-dressed, with men in their fedoras and women in their dresses and high heels. There are the strange juxtapositions, like a horse and delivery wagon parked alongside a polished new automobile. "Self-service" signs can be seen outside grocery stores, harking back to a time when customers still had to ask for most goods behind a counter. There are also stores that would have very little purpose in today's world. Corset

shops, flophouses, and supper clubs are rare now, if not extinct. Then there are the store-front signs made of shiny, enameled metal and neon, which had more pizzazz than today's vinyl awnings and signs cluttering storefronts.

And yes, as these photographs attest, people mingled with their neighbors more. People are often pictured on the streets and stoops, chatting away with one another. But we tend to forget that neighborliness was often made out of necessity. Communication and travel were a lot harder, so depending on neighbors was essential. Also, there weren't as many diversions as there are today. And let's not forget how unforgiving summers could be without air conditioning in a New York City brownstone.

But in these tax photographs, there is indeed a feeling of comfort. Though many decades have passed between then and now, there are many similarities. It's one of the reasons these photographs are so intriguing. For one, the hustle and bustle New York City is famous for is front and center in these photographs. People walk confidently and purposefully, heading to their next destination just like they do today. The mundanity of life we all experience is also on display. Bored people wait for a bus, a woman stands outside a storefront staring blankly at a wall, men look irritated at having their pictures taken—experiences we're all familiar with today.

It's also heartening to see from these images just how many buildings and their ornamentation have stayed the same. Even the occasional sign has managed to survive into the 21st Century. And even more incredible are the establishments that have actually stayed in business for all these years. Places like Gallagher's Steakhouse, P.J. Clarke's in Manhattan, and Schmidt's Candies in Queens are all included in this book.

Some photographs reveal cultural trends not so different from ours today. There are advertisements of "new releases" for movies such as *Pinocchio, The Philadelphia Story,* and *Gone with the Wind,* which are all American classics. Other advertisements reveal that New Yorkers back then loved pizza, Coca-Cola, and Pepsi as much as we do now.

The unvarnished side of city life is also exposed. Vagrants with pained looks on their faces loiter around the Bowery, and hardworking laborers in the Bronx are pictured filthy and strained. There are even tarpapered shacks across all five boroughs that many of us would not find fit to park an automobile in but are, in fact, living quarters.

As for myself, putting this book together took me to the far corners of New York City, and I met all sorts of people along the way. Besides learning so much more history about New

York City, I also came away with a nice realization: Regardless of someone's socioeconomic status or whether a place is in a fashionable zip code, people across New York City take pride in their neighborhoods. On almost every outing, I was approached by curious locals who would give me useful information and interesting stories about their neighborhood. Often, it was seemingly insignificant history that was the most fascinating. For instance, at the Patterson Housing development in the Bronx, an 80-something-year-old woman helped me trace down a long-forgotten street that had been rerouted in the 1950s for the development of the complex. We managed to find traces of the road, which is now part of a pedestrian pathway. Or in Mott Haven, a young man chatted me up and helped me find the brownstone I was looking for, then took me to a bodega that amazingly once housed a vaudeville theatre. Classic businesses still open after all these decades graciously let me photograph their interiors.

Not only are these tax photographs fun to view, they also illustrate that we live in a city of layers and incredible diversity. Block by block, we see era upon era stamped on the city, and we all absorb some of that into our everyday lives. The shadows of the Civil War, the Great Depression, and 9/11, among other time-frames, all made marks on their cityscape. And if you know where to look, yesterday is still here.

Manhattan

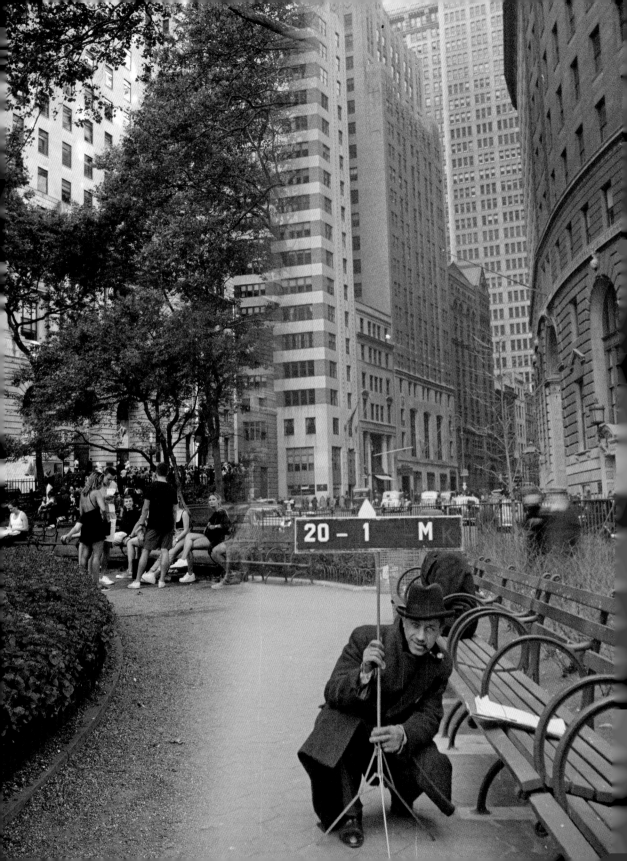

29 Broadway

This general-use office building, built in 1931, is an Art Deco masterpiece that rivals the Empire State Building and the Chrysler Building. Much of the designs and accoutrements are still in place, giving it a never-ending feeling of forwardness and optimism. The man is crouching at one of the most historical spots in New York City, Bowling Green, where the Dutch originally settled in New York. They built a fort here and declared it "New Amsterdam."

As the city grew, this site became the first public park in 1733. More importantly, it was a public meeting place, particularly during the American Revolution. In fact, in 1776, after the Declaration of Independence was read to Washington's troops at nearby City Hall Park, Revolutionaries came down to Bowling Green and toppled the statue of King George III. Pieces of the lead statue were said to have been made into bullets to fight the British. The fence, which was installed here in 1771, is original. After Revolutionaries went after King George's head, they hacked off the fence's finials. Saw marks are still visible.

To the left of 29 Broadway is the Cunard Line Building. This was the famed British ship liner's New York headquarters until 1968. The first-floor lobby depicts fantastical travel scenes in its Great Hall.

To the right of the park is the Standard Oil building, at 26 Broadway. On this site once stood the house of Alexander Hamilton, the first U.S. Secretary of the Treasury.

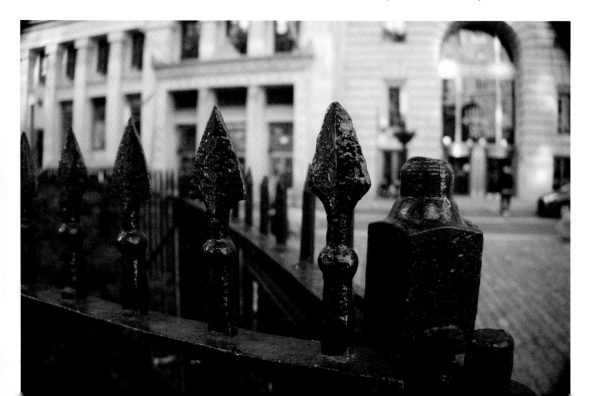

191 Greenwich–World Trade Center District

Of course, the terrible destruction of the World Trade Center on 9/11 and the erection of a new tower have completely transformed this area. But few people know this was once a bustling neighborhood for immigrants, with Syrian shops and brownstones dotting the streets. It was also known as the "radio district." The shops grew out of the burgeoning hobby in the 1920s.

The Wm. Infeld haberdashery, a men's clothing store, was established in 1885. Signs in the shape of their wares, like this shirt, were common in the 19th and early 20th centuries. Many immigrants didn't speak English, and the signs helped direct customers.

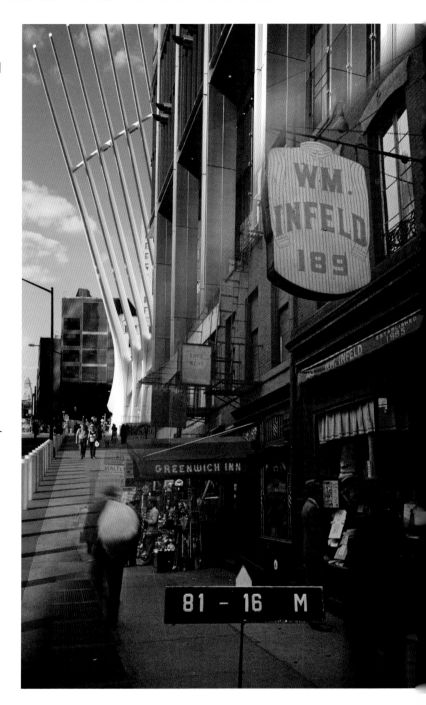

193 Greenwich Street–World Trade Center District

These photos provide a different angle of the same area near 191 Greenwich Street. A hodgepodge of goods for sale included gardening supplies, fishing tackle, and bar supplies—one cheery sign even proclaimed, "Canaries one flight up." The elevated train, once a loud, powerful presence in the neighborhood, is gone.

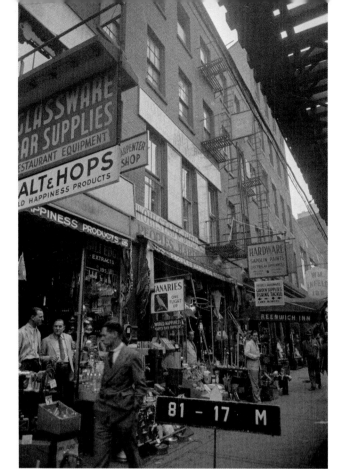

2 White Street—The Gideon Tucker House

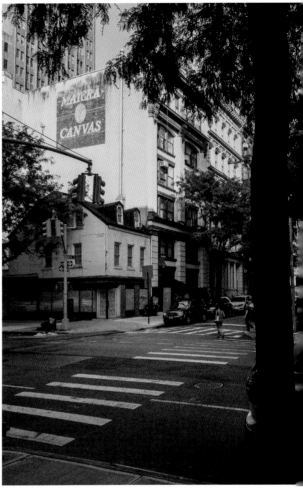

Even in eclectic Tribeca, this Federal Style house sticks out from the crowd. Gideon Tucker was a city alderman and owner of a plaster factory located on the same lot. He built the brick and wood house for his family in 1809. A multitude of shops and businesses have been here over the centuries, including a barber shop, restaurant, and cigar store. Around the time of the Civil War, the basement housed a dance hall called Shadow City. Federal Style houses were commonplace in Manhattan until the mid-20th century, but a few remain. Fortunately, the Gideon Tucker House has been granted New York City landmark status.

363-367 Greenwich-Street Hotel Bar Butter

Though the company moved out decades ago, Hotel Bar Butter, which was founded in 1885, is still a popular brand in the Northeast. This building and the surrounding area are part of the now-named Tribeca (aka Triangle below Canal Street). For many years, this neighborhood was a warehouse district specializing in the wholesale food business. Today, the neighborhood is considered the best-preserved collection of 19th-century warehouse architecture in the world. Many of the warehouses have been renovated into multimillion-dollar loft apartments.

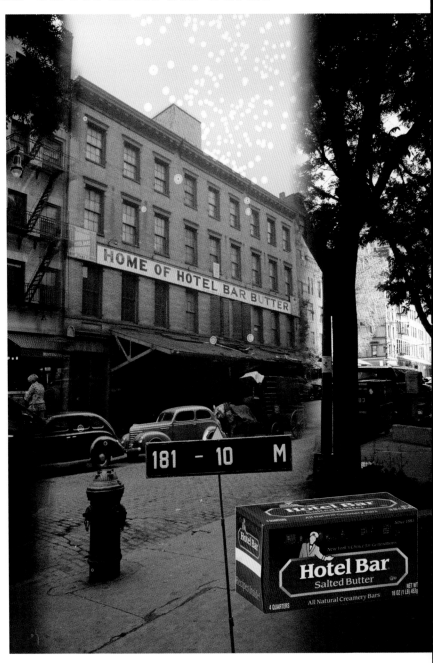

355-359 Greenwich Street

Poultry
Eggs
Butter

Largest Individual and Best
Equipped Plant in New York

INSPECTION INVITED

De Winter & Co. Inc.

COMMISSION MERCHANTS

521 Washington Street,
554 Greenwich Street,
97 to 85 Jay Street,
(One Building.)

New York

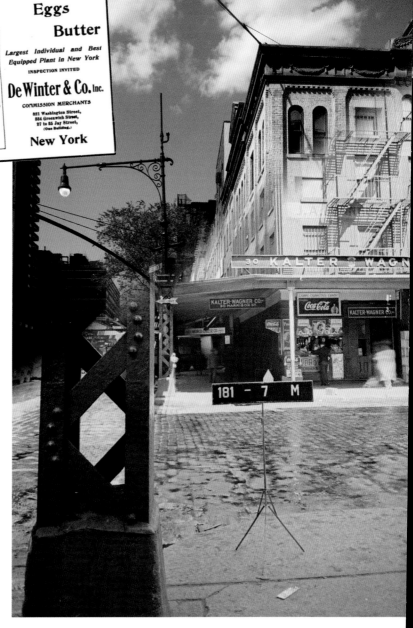

This former warehouse, built in 1891, housed several food wholesalers. Tenants included a salt lick manufacturer for livestock. Another, the Zenith Butter & Egg Company, made national news in 1909 after a shipment of eggs from the Midwest arrived partly hatched. Sadly, none of the chicks survived the journey. Even today, faint signs of companies like A. Bernholz & Sons can be seen on the second and third floors.

13 Doyers Street–Nom Wah Tea Parlor

First opened in 1920, Nom Wah Tea Parlor is not only the first but the oldest dim sum restaurant in New York City. Located in Chinatown, they are still serving "little meals" of dumplings, buns, and cakes. Incredibly, the restaurant has changed ownership only once. The Tang family has been running it for decades.

The interior still holds much of its original charm, with booths and tables looking like they're straight out of an Edward Hopper painting or film noir.

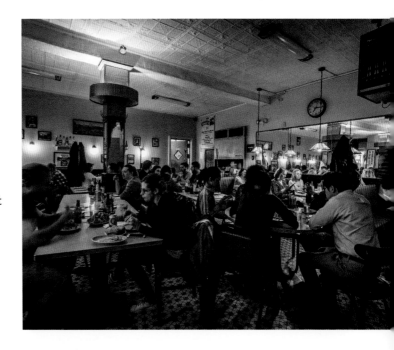

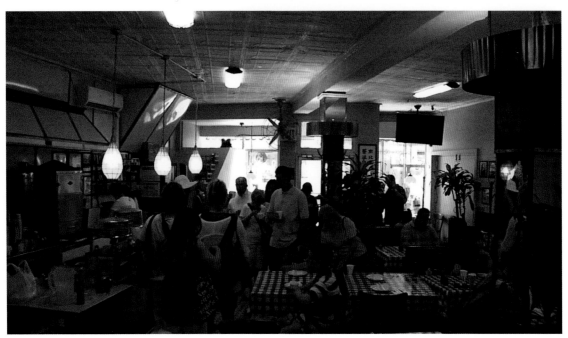

17 Pell Street–Ting's Gift Shop

Ting's has been here since 1957 and is one of the oldest businesses in Chinatown. Generations of tourists have bought unusual trinkets at this little corner gift shop. In 1958, some of the "merchandise" was serious contraband, as police found 10 pounds of heroin in a raid. According to *Life* magazine, the place was allegedly a drug-supply point in New York City. *The New York Daily News* reported that customers would give a code word and then ask for a small novelty pillow which would have heroin hidden inside.

19 Pell Street–Mon Hing Co.

At the time this tax photo was taken, 19 Pell (directly across the street from Ting's) was a local restaurant supply company. However, in the early 20th century, the apartments above housed quite a few unsavory characters. More than a few were suspected Chinese gang members, and at least one murder occurred right outside this address. A gang war left seven injured here in 1917. Today, the only clipping going on here is in the first-floor barber shop.

Look carefully on the side of 19 Pell Street, just above the corner. The street sign nailed to the outside can be seen in both the then-and-now photos.

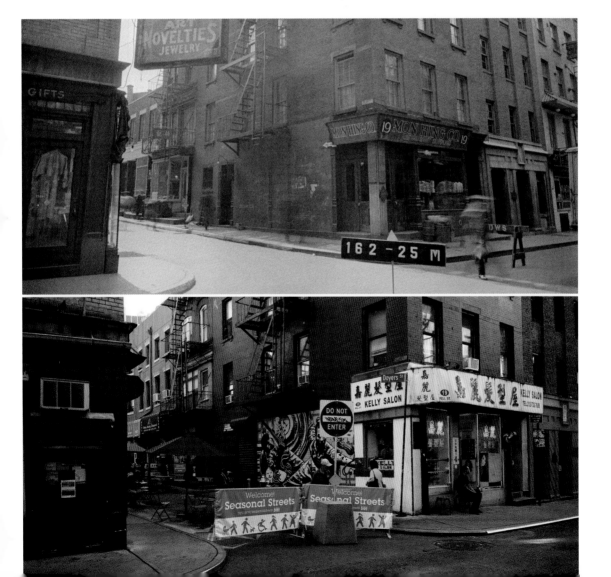

9 Doyers Street

Together, Doyers and Pell streets have one of the most notorious histories in New York City. You might not believe it now, given today's relaxed and cordial atmosphere, but during the 19th century and part of the 20th, this spot was known as the "Bloody Angle" and "Manhattan's Murder Capital."

Warring gangsters, mostly Chinese gangs, used the crooked road to ambush their rivals. Assailants took advantage of a blind spot to shoot or stab their victims, then escape through a nearby passageway. That passage is still there, though it's now a drab strip mall catering mostly to medical offices. 9 Doyers may have also once been an opium den.

Next door to 9 Doyers Street is the Rescue Society's Midnight Mission, a religious aid society for the homeless. For decades, the place housed a Chinese theater attended by both locals and tourists. In 1895, the owner was arrested for holding shows on Sunday. The police commissioner sided with the theater owner, stating he was being persecuted, and dropped the charges. That commissioner: future President Theodore Roosevelt. Today, the spot is a hip speakeasy-type cocktail bar.

238 South Street–Lunch Room

Located directly across the street from the East River, just under the Manhattan Bridge, this no-frills joint most likely catered to longshoremen and laborers. Just a stone's throw from South Street Seaport, the area was full of wharves and warehouses. Ships imported and exported goods and materials from around the world. In many ways, this small part of Manhattan led to the explosive growth of New York City and the rest of the United States in the 19th and early 20th centuries.

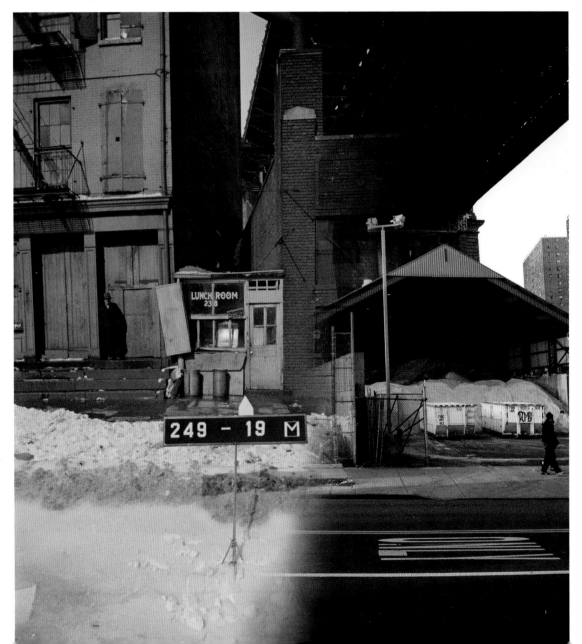

205 East Houston Street-Katz's Delicatessen

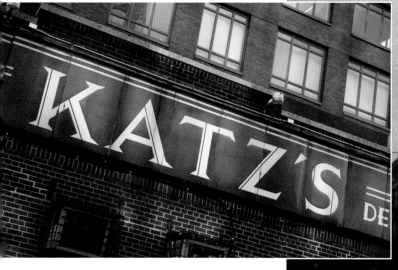

Opened on the Lower East Side in 1917, Katz's is one of the best-known delis in New York City, if not the world. One particular menu favorite is their pastrami on rye. They sometimes take 30 days just to cure the meat.

Katz's interior looks pretty much the same as when the tax photo was taken. The large cafeteria-style room has an Art Deco feel to it. The scene in the movie *When Harry Met Sally* (1989) in which Meg Ryan shows Billy Crystal how women, ahem, "fake it" was shot here, along with other television shows and movies.

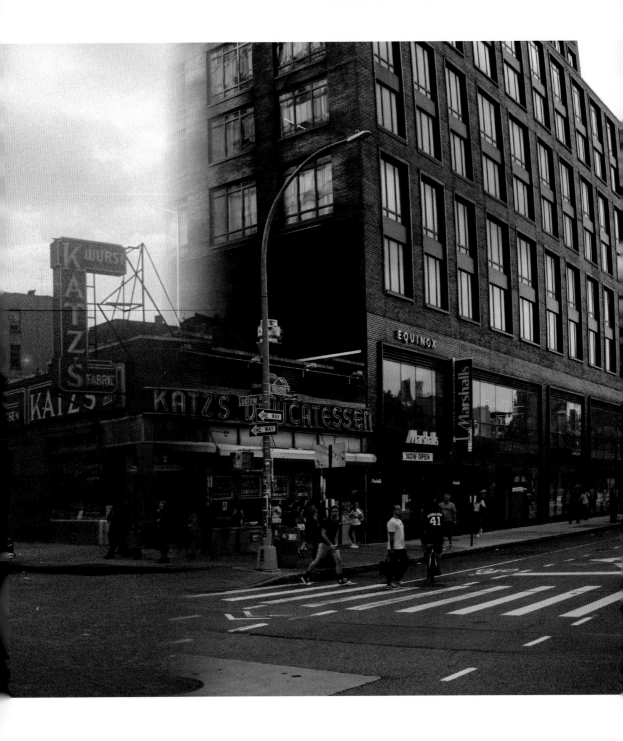

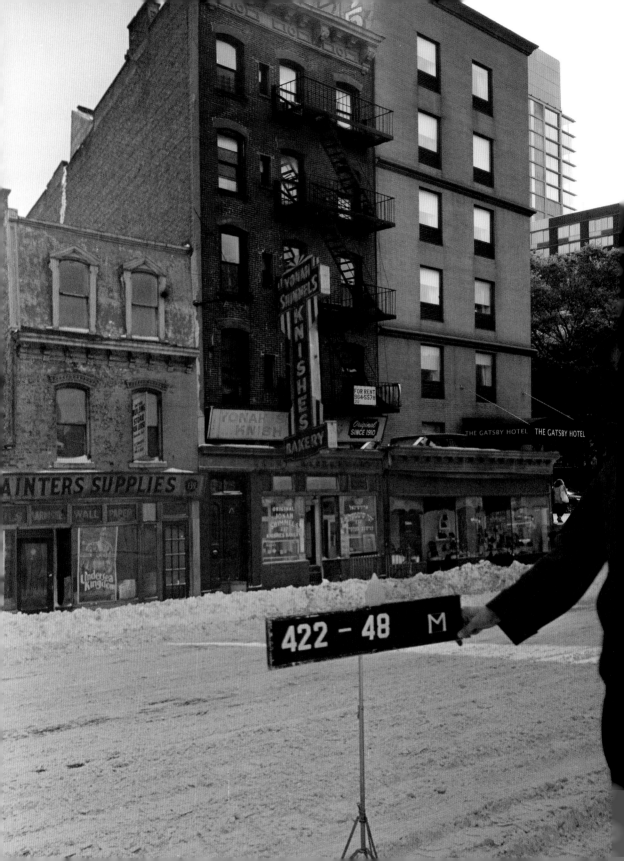

137 East Houston Street–Yonah Schimmel Knish Bakery & Restaurant

Another Lower East Side institution, Yonah Schimmel Knish Bakery has been baking knishes here since 1910. A *knish* is a thinly wrapped, layered baked dough, usually filled with potatoes or onions, among other ingredients.

Mr. Schimmel started the business on a Coney Island pushcart in 1896. Knishes were a popular snack in Old World Eastern Europe. Yonah's is the last original knish bakery in Manhattan. First Lady Eleanor Roosevelt, singer Barbara Streisand, and TV star Larry David have all stopped in for a bite.

154 Stanton Street-Louis Zuflacht Building

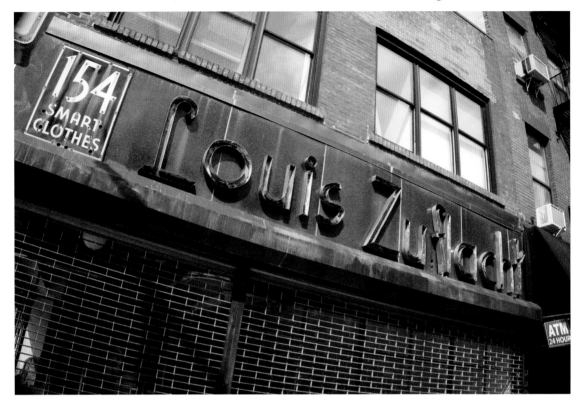

Although the building's namesake business shuttered decades ago, the owners have had the foresight to keep the sign. The building was built sometime in the 1860s. Louis Zuflacht was a men's haberdashery store owned by Mr. Zuflacht. He had a long life, being born in either 1881 or 1883 and living until 1986. In 1985, according to local newspapers, Mr. Zuflacht went through quite an ordeal. He was complaining of shortness of breath at his Miami home, and an ambulance arrived to help. While the medics were loading him onto a stretcher, the ambulance was stolen. The medics and Mr. Zuflacht were left waiting twenty minutes before another one arrived. Fortunately, he survived the incident.

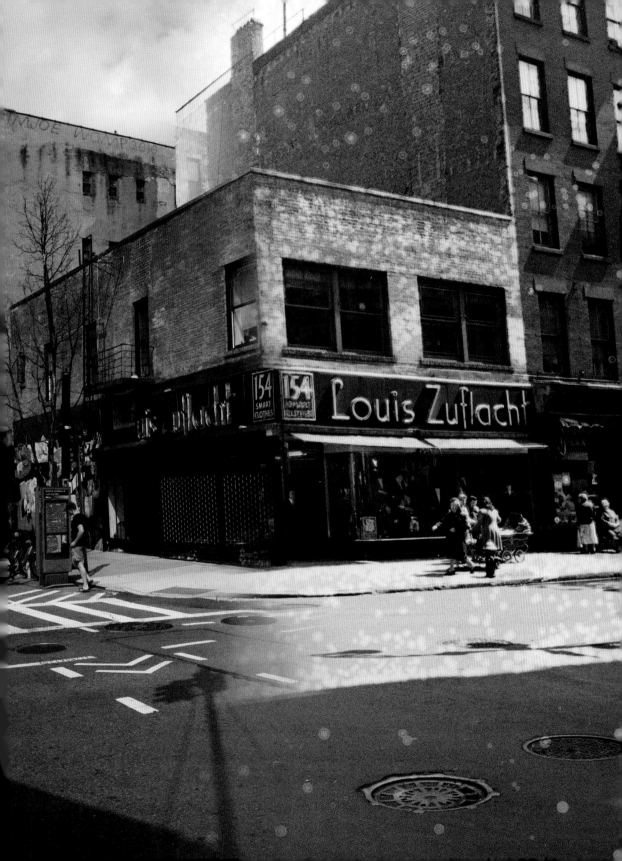

105-107 Ludlow Street

This corner of Ludlow and Delancey could not be more representative of what helped define the Lower East Side as a clothing store district. Crawford's touted itself as the "Largest Store in the East," and it specialized in clothes for men. To the left is Hass Shoes, which manufactured shoes in nearby Newark, New Jersey. Nearby is the venerable Florsheim Shoes, which once seemed to be on every town square and in every mall in America.

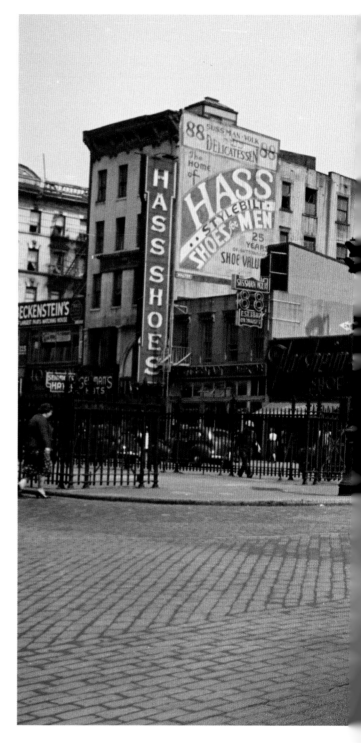

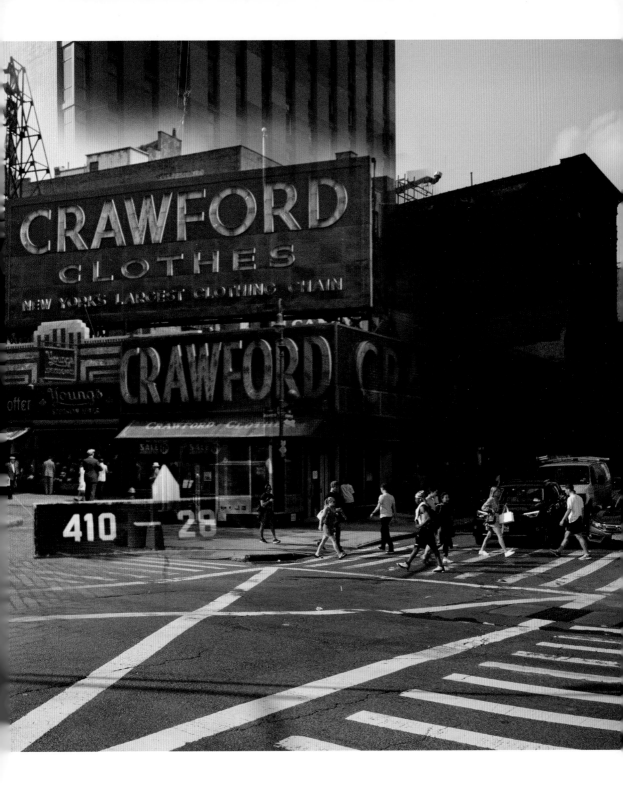

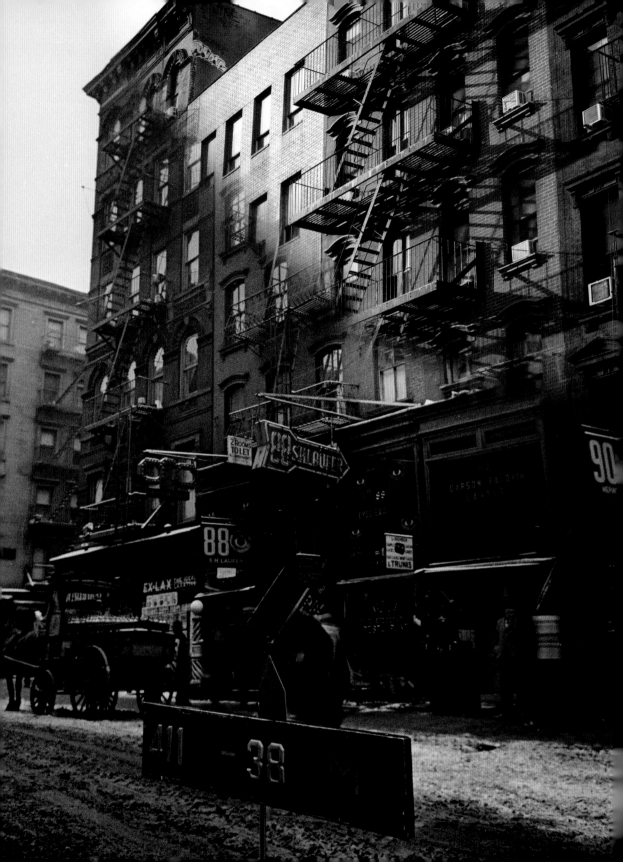

88 Rivington Street

Optometrists maintain their presence on the Lower East Side. One such store—MOSCOT on Orchard Street—has been a mainstay on the Lower East Side since 1936. Shops with signage in Hebrew attest to how large the area once was as a Jewish immigrant enclave. Now, fashionable bistros, high-end apartments, and experimental art galleries rule the area, but there's still evidence of the Old World in this neighborhood, with some families going back generations.

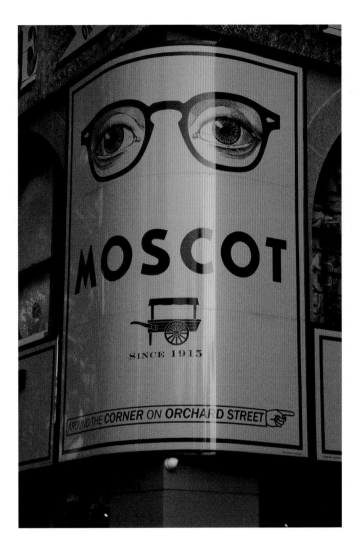

146-150 Orchard Street

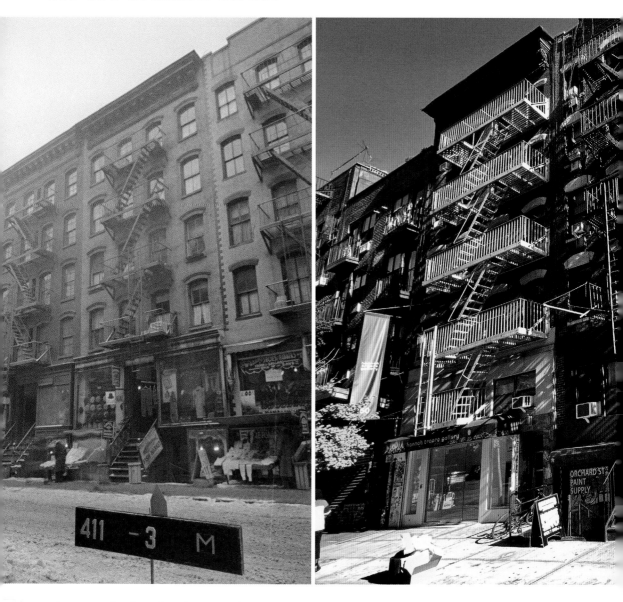

This stretch of Orchard Street shows just how much of a melting pot the Lower East Side was, not just in ethnicity but also in goods and services. A shoe store and hat shop are wedged in with fish markets. A Jewish market stands next door, while nearby is a dry goods store and a fruit and vegetable market—and that's only half the block.

149-157 Orchard Street

Another row of Orchard Street shows the mix of goods offered on the streets of the Lower East Side. Shopkeepers' wares pour out onto the sidewalks, tempting pedestrians to browse.

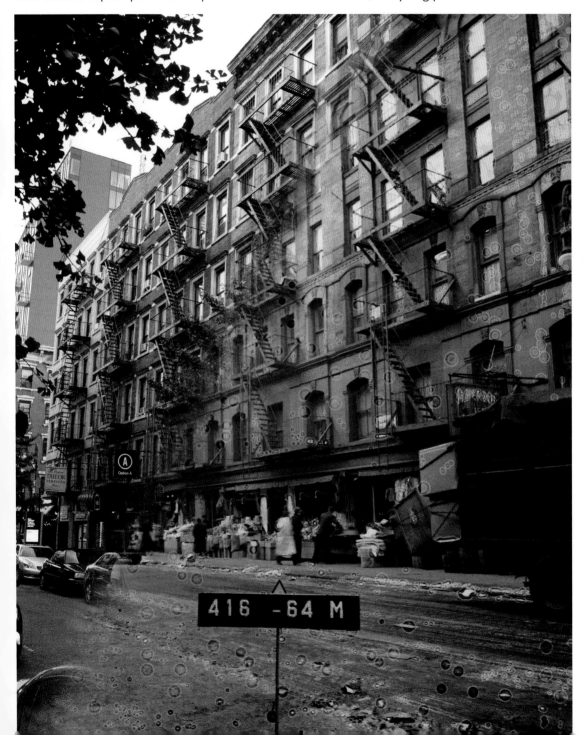

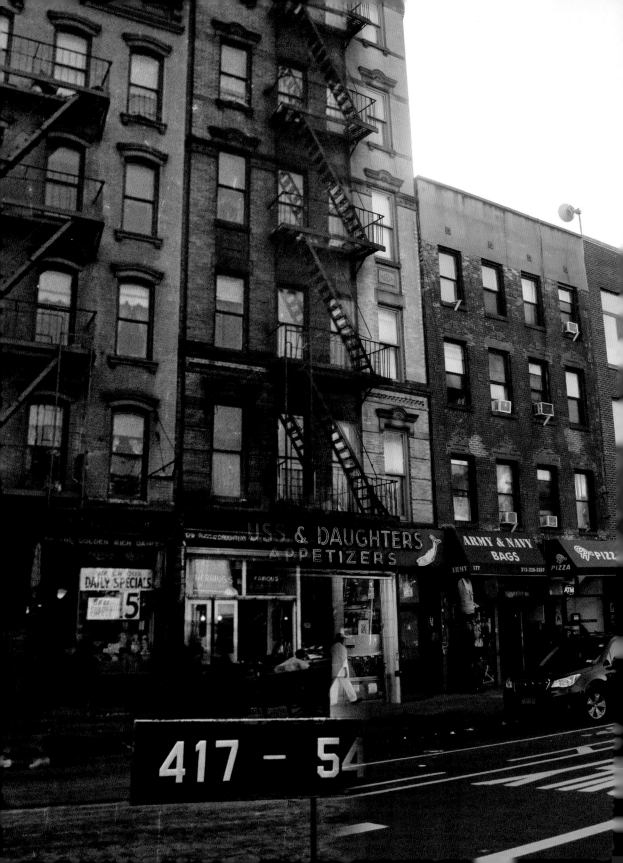

179 East Houston Street-Russ & Daughters

Polish immigrant Joel Russ started Russ & Daughters in 1914, moving to this location in 1920. Amazingly, it's still run by the same family, with Mr. Russ's great-grandchildren taking over the reins.

The store's name was quite a head-turner in the early 20th century. Though it was common for owners to take their sons and daughters into the family business and rename it "and Sons," no one had ever heard of naming a place "and Daughters." Russ had three children, all girls, and they all went into the business. The family says there was no ill will toward the sign, but rather lots and lots of confused looks.

Russ & Daughters is an *appetizing store*—a throwback business to Old New York. *Appetizing* originates from the Jewish culinary tradition of separating certain foods for religious reasons. A general definition is a store that sells fish and dairy products. It can include other foods that are generally eaten on a bagel. Similarly, delicatessens were set up in the Jewish faith to sell meat products. Today, delis have evolved into mostly sandwich shops. However, some rare appetizing stores still exist in heavily populated Jewish areas, particularly in Brooklyn.

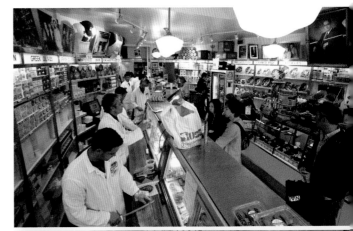

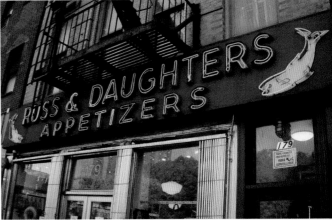

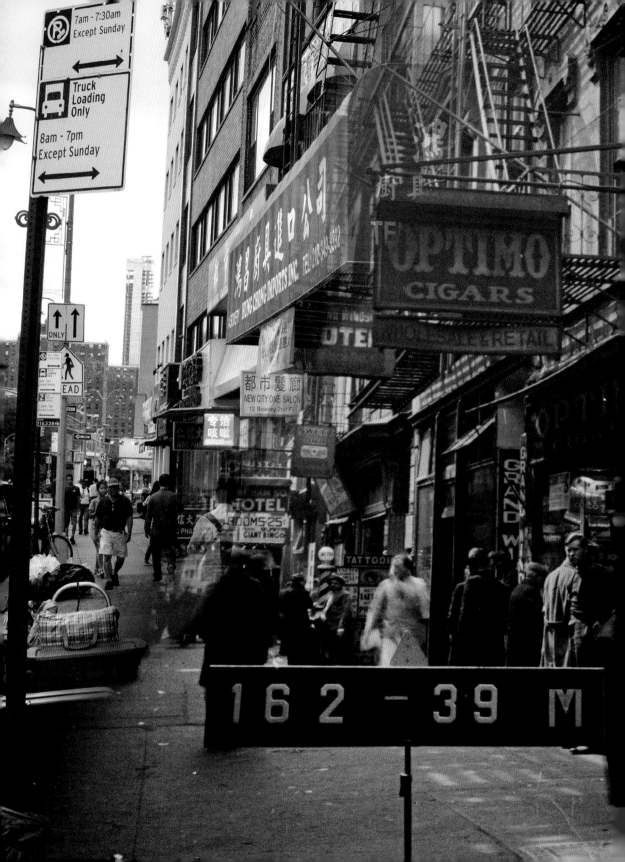

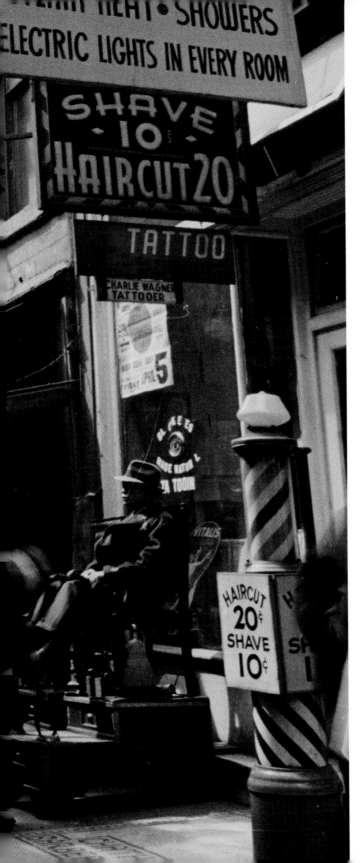

7-8 Chatham Square

Signs on this south section of the Bowery were rich with irony. Descriptions like "Progress Hotel" or "Modern Improvements" did little to hide the ill repute. Tattoo parlors and the promise of "Electric Lights in Every Room" hint at the Bowery's seedy underbelly.

Even in the 19th and early 20th centuries, the Bowery neighborhood in downtown Manhattan had such a sordid reputation that "slumming tours" were in vogue so the upper classes could "see how the other half lives." Some tours included actors to play up the vagrancy. With its streets lined with cheap booze joints and flophouses, it was America's most famous skid row. Today the area has undergone gentrification, but some of its past is still on view.

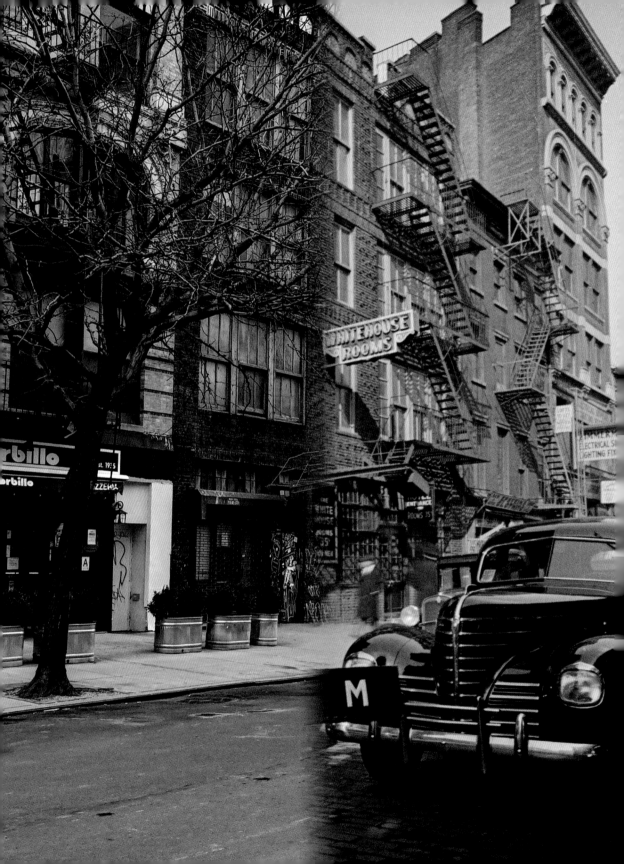

333 Bowery– White House Hotel

The White House opened here in 1917 and was one of the more notorious flophouses on the Bowery. Its name was not to conjure up images of the White House in our nation's capital. Rather, it was said to be code for "Whites Only."

Flophouses catered mostly to poor, transient, often mentally ill and/or addicted men, and the White House Hotel was one of the last to exist in the Bowery. Floors were divided into 6- by 4-foot cubicles with chicken wire on top. Occupants were provided with a small bed, but the bathrooms were communal. Often men would become residents, staying here for months, sometimes years.

Most flophouses died out in the 1950s. Up until a few years ago, brave tourists, usually European backpackers, could still rent a night or two at 333 Bowery.

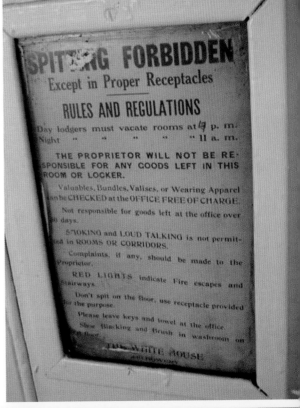

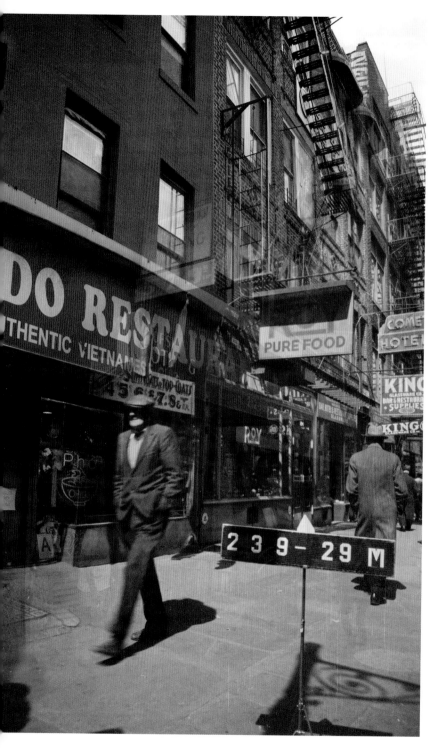

104-106 Bowery

Down-and-out men filled the streets of the Bowery. Ordered out of the flophouses by day, many men shuffled along the streets among the cheap stores until they could muster up enough money for a drink.

In the background you see the Comet Hotel, another notorious flophouse that was once known as the Stevenson Hotel. It was built somewhere in the 1850s. At one time, the bottom floor housed both Yiddish and Italian theaters and, not surprisingly, a beer hall. Over the years, newspapers reported numerous robberies, murders, and even one man expiring on the sidewalk after having his last drink.

219 Bowery

Among the neighborhood's flophouses, bars, and pawn shops, culinary supply companies dotted this area of the neighborhood. Today, not only are some culinary supply stores still here, but vestiges of the predecessors are still on view too. Close inspection of 219 Bowery reveals the same signage as when the tax photo was taken.

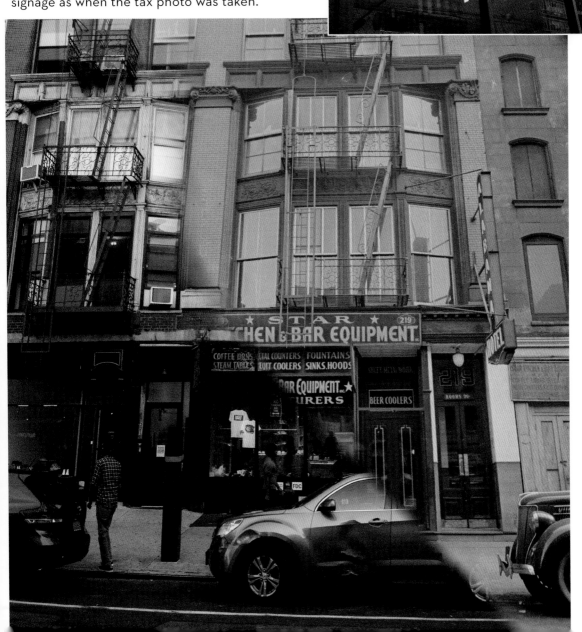

276-278 Bowery

Another view of just how much the Bowery has changed over the decades. Men in overcoats standing outside a flophouse are replaced today by bank branches and women in yoga pants. In the background one can see the notorious Uncle Sam House, It opened its doors in the 1890s, and it was put out of its misery in the late 1970s. Today its ceramic tile sign can still be seen in the entryway.

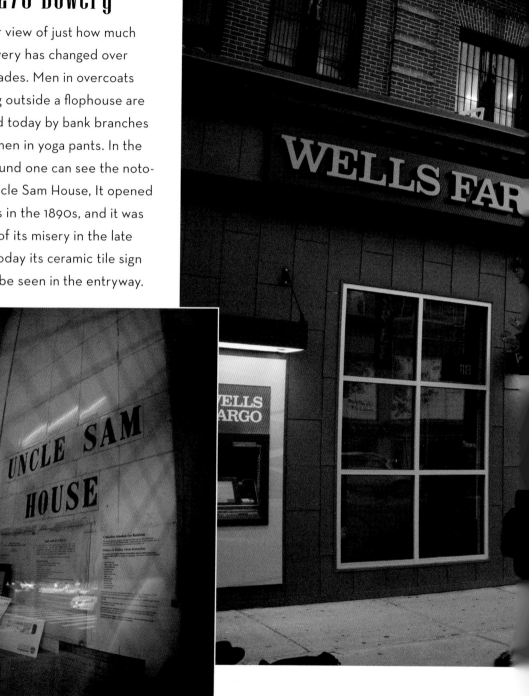

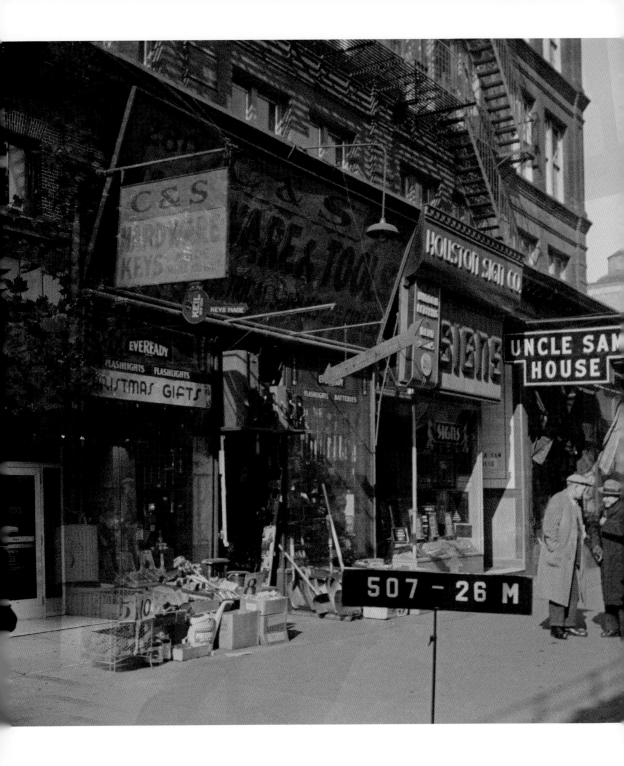

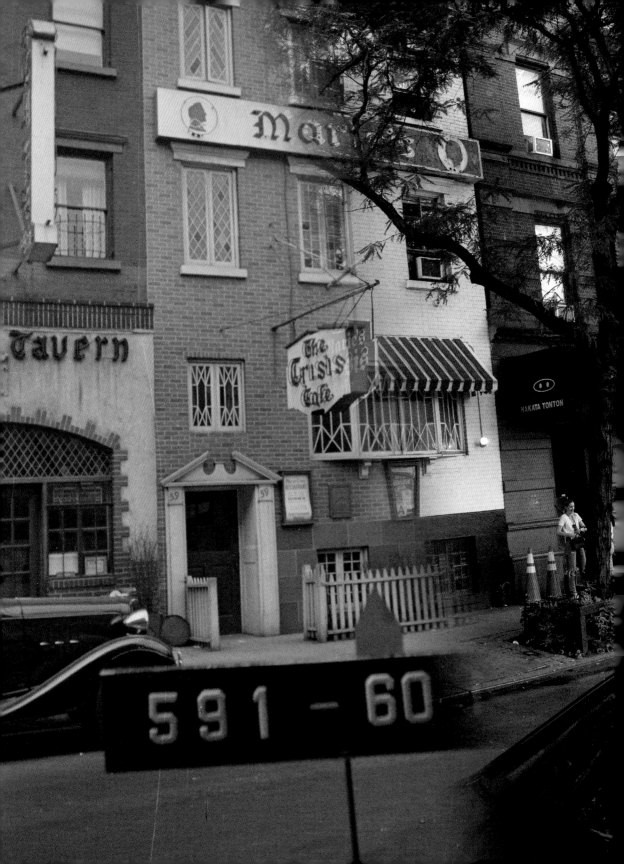

59 Grove Street–Marie's Crisis

Greenwich Village is the city's original bohemian enclave, and thanks to places like Marie's Crisis Café, it still holds much of its authenticity as coffee shops and juice bars strangle out the old guard. The little plot of land Marie's Crisis sits on has seen a lot of history. Thomas Paine, who wrote *Common Sense*—a booklet that laid out why the American colonies should walk away from England—died on this spot in 1809 in a little wooden house. The current building was built in 1910, and singer Marie Dumont opened her café there in 1929. She named the establishment for one of Payne's lesser-known works, *The American Crisis*, which implored soldiers to reenlist ("These are the times that try men's souls . . .").

In the 19th century, this spot was one of a very few gay bars located in New York City. A brothel catering to both persuasions was said to operate upstairs. Today, Marie's is one of the premiere piano bars in the city.

57 Grove Street– Arthur's Tavern

This is another of Greenwich Village's famed music venues, specializing in jazz, blues, and R&B. Arthur's also features regularly the more rarified music of Dixieland jazz. First opened in 1937, it has hosted Charlie Parker and Roy Hargrove, among other jazz and blues greats. The building was built in 1910.

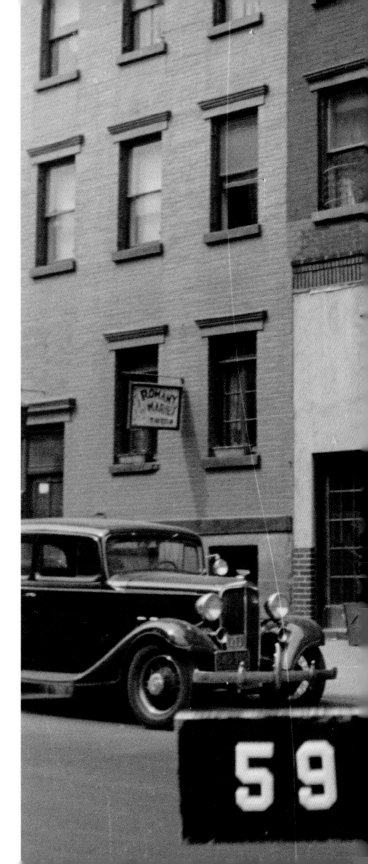

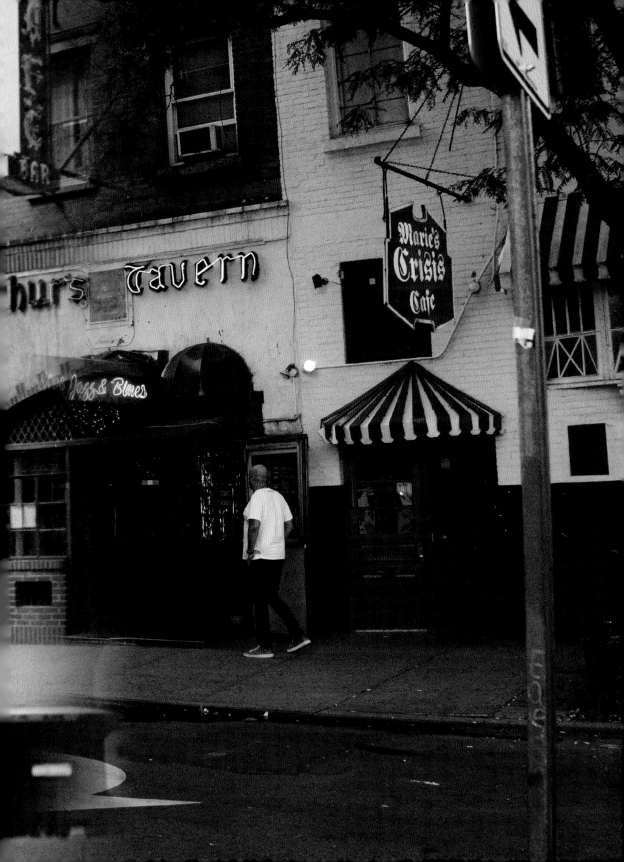

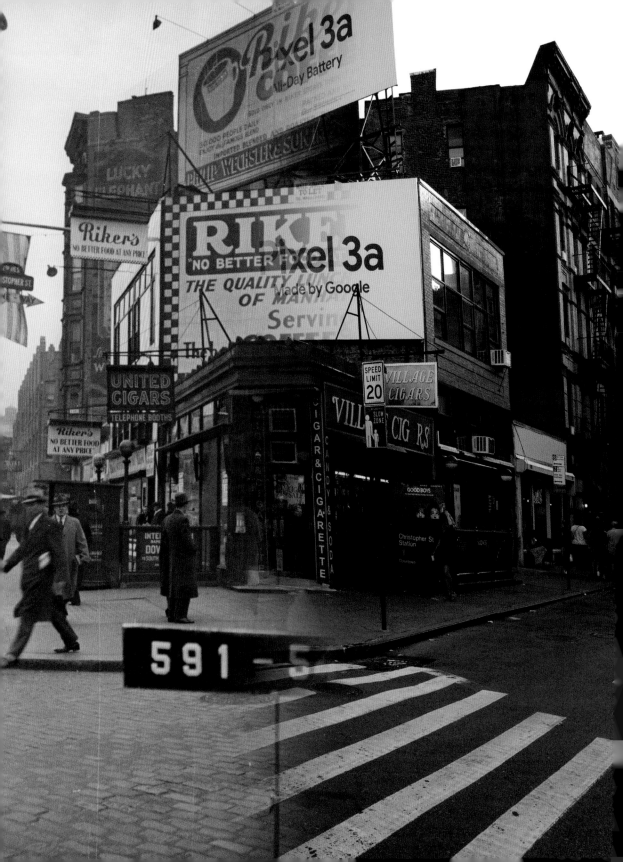

110 7th Avenue South—Village Cigars

Village Cigars has been located in this small triangular building since 1922. Just outside the entrance is a black and yellow mosaic triangle which states, "Property of the Hess Estate, which has never been dedicated for public purposes." It can even be seen faintly in the tax photograph.

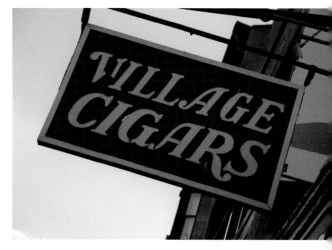

It stems from a land dispute in 1913 in which the city declared eminent domain on neighboring buildings to expand 7th Avenue South and the subway. One holdout was real estate owner David Hess, who owned an apartment building. He eventually caved, but years later his family discovered the city had actually missed this tiny spot in their takeover. (It can even be seen as lot 55 on a 1916 map.) The city wanted the family to donate the tiny plot, but instead they kept it and installed this 25.5- by 27.5- by 27.5-inch mosaic plaque in defiance. For a time, it was the smallest privately owned piece of property in New York City, but in 1938 the sliver of land was sold to the cigar shop owners for a thousand dollars. And yes, the tiny plot of land was and still is taxed by the city.

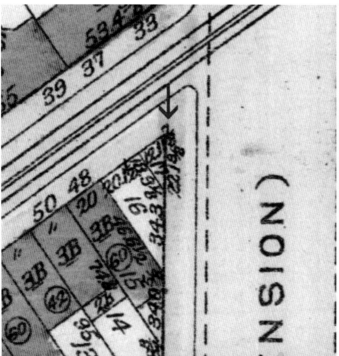

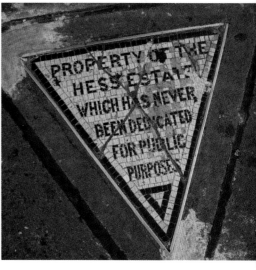

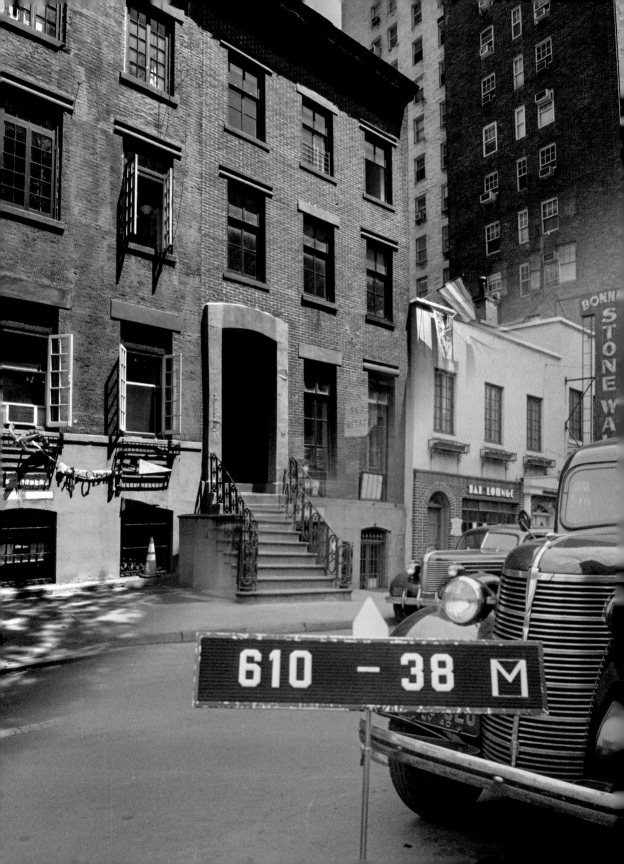

BONN
STONE WA

BAR LOUNGE

610 - 38 M

51-53 Christopher Street-The Stonewall Inn

One of the most historic bars in America, the Stonewall Inn is where in 1969 a group of gay men were busted by police during a planned raid. The arrestees rioted, touching off the symbolic start of the gay rights movement. Today, it is still open and is a national monument under the National Parks Service.

Originally named Bonnie's Stonewall Inn, it began as a speakeasy disguised as a tearoom. At the time this photograph was taken, the bar was a restaurant/nightclub and not officially a gay bar. It was not until the Mafia bought a stake in the bar in 1966 that it started catering to gay people. Often the mob preyed on the gay community, opening up cheap bars offering "protection." They also shook down patrons with threats of publicly outing them, all the while bribing law-enforcement on future raids and information on individuals.

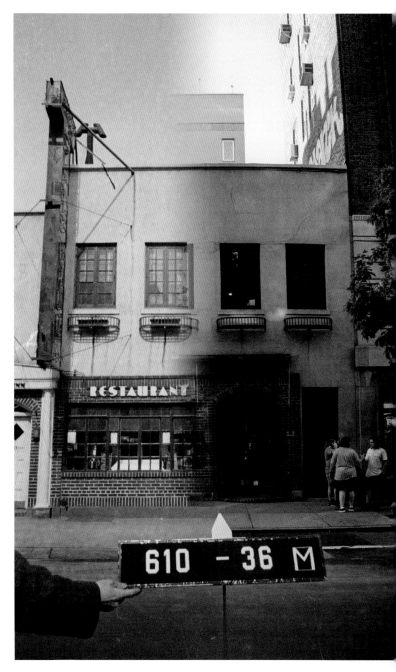

15 East 7th Street–
McSorley's Ole Ale House

McSorley's is one of America's most storied bars. Established in 1854, not much has changed literally since it opened. The interior is a rare step back into the mid-19th century. The wood-paneled walls are lined with memorabilia and photos, much untouched from at least 1910. McSorley's famous clientele include General Ulysses S. Grant, President Teddy Roosevelt, and e. e. cummings, who even wrote a poem about McSorley's. Future President Abraham Lincoln even visited here after he made his famous speech at the Cooper Union college nearby.

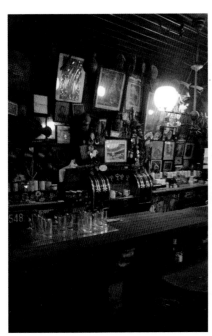
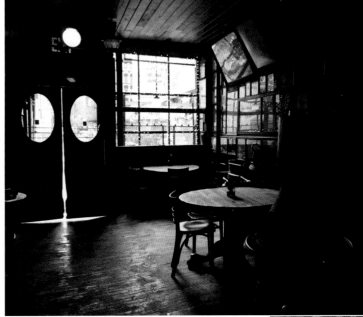

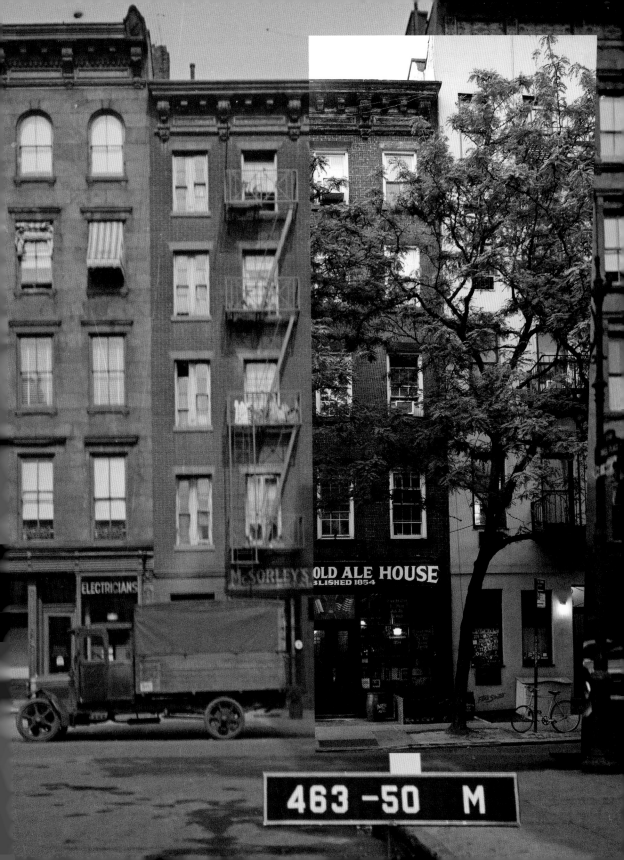

ELECTRICIANS

McSORLEY'S OLD ALE HOUSE
ESTABLISHED 1854

463-50 M

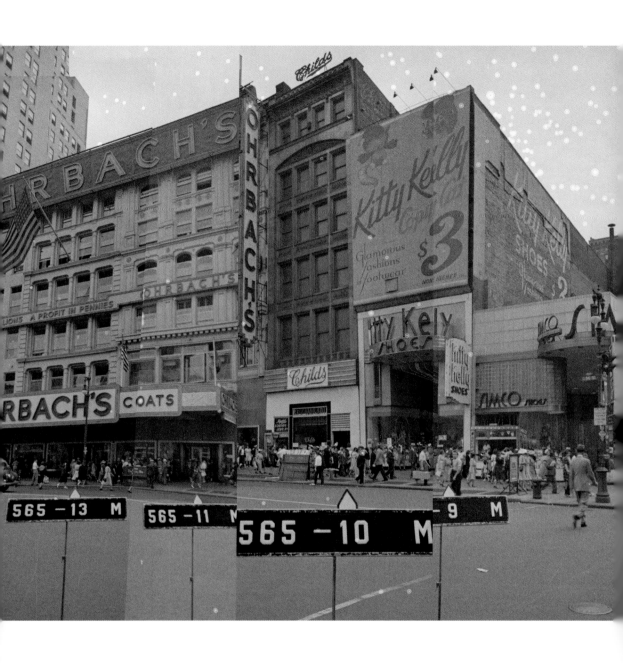

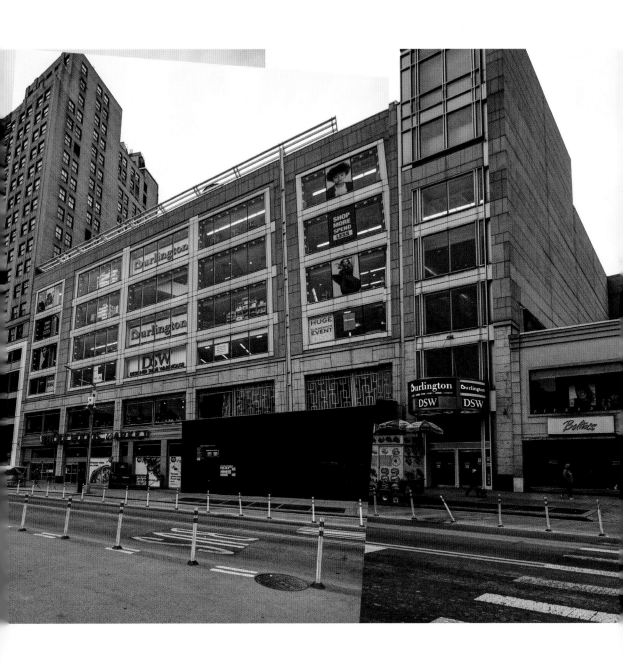

46 East 14th Street-Ohrbach's

Nathan M. Ohrbach founded this discount clothing store chain here in 1923. Before Ohrbach's, the building housed the first nickelodeon in New York City.

One of Ohrbach's cost-cutting gimmicks was pricing merchandise only in even numbers. They were adept at buying overstock, irregulars, and factory seconds. To further undercut their competitors, they were strictly cash-and-carry, and they offered no sales or advertising. Ohrbach's left this location in 1954, but the company lasted until 1987.

40 East 14th Street-Kitty Kelly Shoes

Yet another discount chain store, Kitty Kelly Shoes owned several stores in the East and Midwest. For years, they declared they were home to the $3 shoe.

42 East 14th Street-Child's Restaurant

Child's was one of the first chain restaurants in America. Starting in New York City in 1889, the company helped usher in numerous restaurant innovations. Their vision was to provide low-cost meals for the middle class while stressing cleanliness in food preparation—a real concern in the late 19th century. Child's restaurants were designed with sanitary-looking white tile and had waitresses in uniforms akin to nurses' uniforms. Child's was also the first to introduce cafeteria-style self-serve meals.

At its height, in the 1920s and early 1930s, Child's had some 125 locations in several states. Curiously, one of the founders, William Childs, tried to impose his vegetarian beliefs on the menu. The change was a flop with customers, and because of it, investors staged a hostile takeover of the company. The chain died out in the 1960s.

72 West 36th Street– Keen's Steakhouse

Housed in three unassuming town-houses, Keen's Steakhouse is one of Manhattan's most beloved restaurants. Opened in 1885, it lays claim to even being the oldest steakhouse in New York City. It is the lone survivor of the "Old" Herald Square Theatre District catering both to theatergoers and actors. Throughout its interior, memorabilia lines the walls, including antique playbills of past Herald Square productions. One particular playbill is of *Our American Cousin*—the play President Abraham Lincoln was attending in Washington, D.C., when he was assassinated by John Wilkes Booth. Legend has it that *this* is the copy Lincoln was holding on that infamous night. Equally fascinating are the thousands of churchwarden pipes displayed on the ceiling. The long clay pipes stem from a tradition in which old English taverns would hold onto a patron's fragile pipe, lest it get broken. Some of the pipes on display include ones owned by or presented to New York Yankee ballplayer Babe Ruth, U.S. General Douglass MacArthur, and actor Tom Hanks.

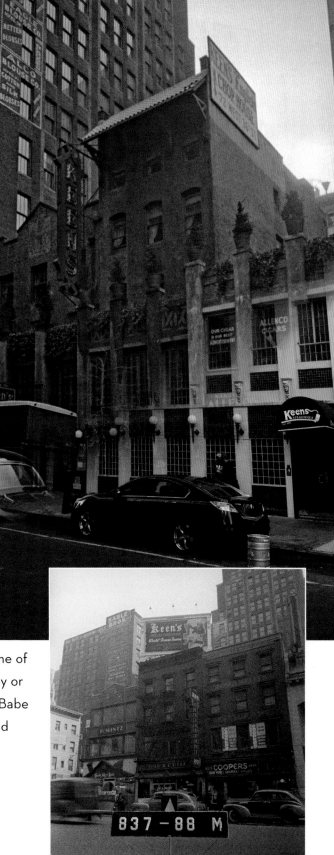

46 West 36th Street & 58 West 36th Street— Lone Brownstones

These two early 20th-century brownstones are rare survivors in Midtown Manhattan. So-called holdout buildings, they are now surrounded by gleaming high-rises whose developers most certainly tried to tear them down.

Holdout buildings survive for a number of reasons, including spite. For one, a real estate developer may have been unable to secure real estate rights from a building owner who is "holding" out for more money. There have also been situations where the owner simply wanted to "stick it to the man." Furthermore, some small businesses actually own their own building and simply refuse to move out. Then there is the matter of New York City's rigid rent control laws, which include situations where tenants will holdout for more buyout money. However, this game of chicken can backfire. Developers will creatively build around the desired space, leaving the holdout under a hulking sunlight-stealing monolith. Not to mention the heightened value of the holdout is gone once the surrounding land is developed.

At 58 West 36th Street, note the remaining wall from the previous building is still attached to its right side. Builders of the 19th century often shared the neighboring building's wall to save space and cut costs and time.

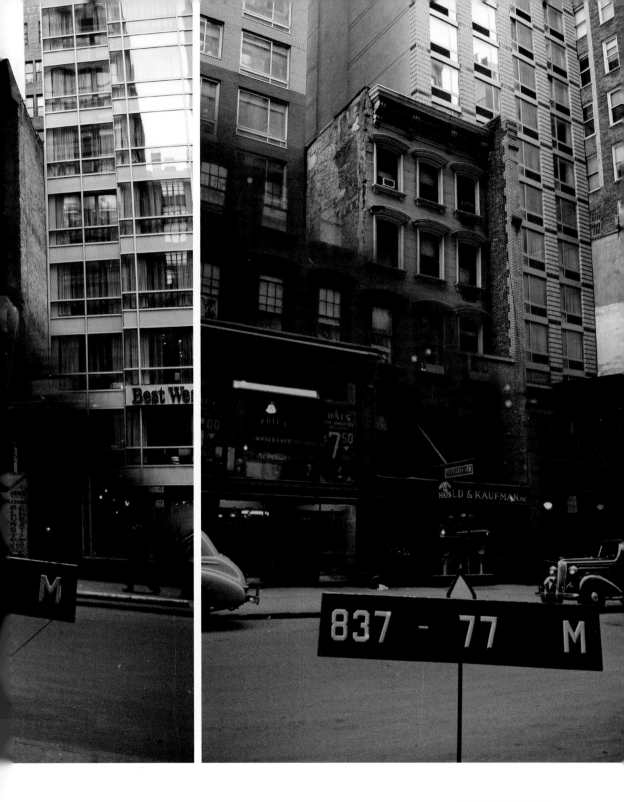

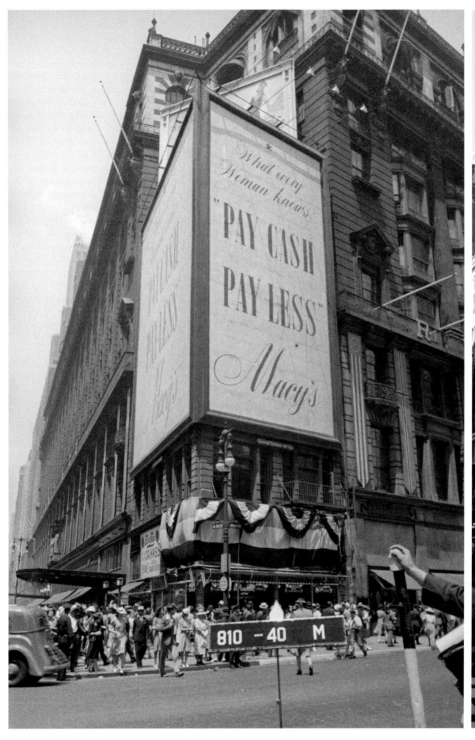

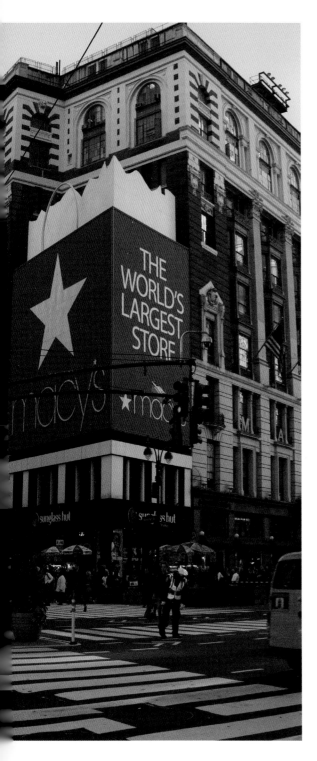

151 West 34th Street– Macy's

Macy's Herald Square is the company's flagship store, taking up a whole city block at 34th Street. At around 2.5 million square feet, it is the largest department store in America. The now-landmarked building, built in 1902, harkens back to the day when stores like these ruled the city.

The building has a curious quirk on its corner at 34th Street and Broadway. Founder Rowland H. Macy was forced to build around the building on the corner due to a real estate dispute. No problem— Macy's now uses the space's roof for advertising.

203 East 29th Street– Wooden House and Brick Carriage House

In the neighborhood of Kips Bay, this wooden house (one of the last in the city) and its brick carriage house are certainly holding onto their secrets. Little is known about the house's history or why it was built. One guess is it was a small farmhouse to an orchard. Even its age is widely disputed, ranging from 1747 to 1845. What is known is that the complex has gone through many iterations, including a junk shop, a sign company, and (its present use) a private residence.

149 East 22nd Street–Gramercy Park

Can you blame these gawking men? With smartphones more than a half a century away, and television still in its infancy, gawking at new construction must have been a stimulating leisure activity. The end result, not so much. Today this is a quiet, well-maintained rental building for a workaday New Yorker.

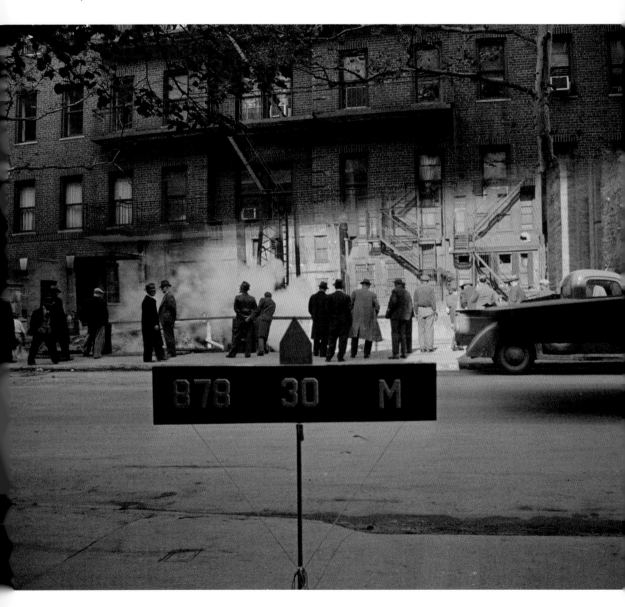

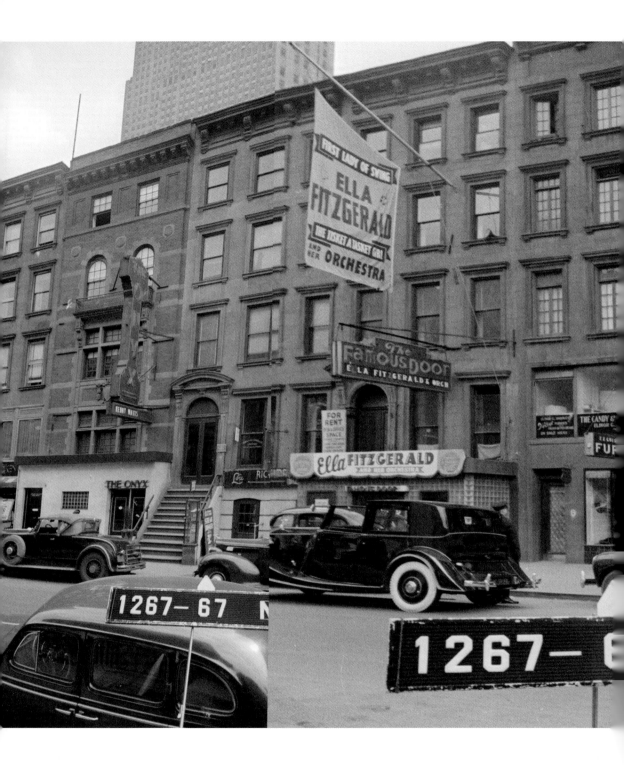

Swing Street–52nd Street

From the 1920s to the early 1960s, some of the best places to hear live jazz in America were along 52nd Street, around 5th and 6th Avenues. Its convenient location next to Times Square's "legitimate" nightclubs and the nearby broadcast and recording studios brought loads of talent here. Performers include Thelonious Monk, Count Basie, Miles Davis, Billie Holiday, Dizzy Gillespie, Bessie Smith, and countless others. Incredibly, almost all of it has been replaced by behemoth office buildings.

62 West 52nd Street–Onyx Club

First a speakeasy, the Onyx Club was considered a more laid-back establishment on 52nd Street. It was thought of as a musician's jazz joint, with people often holding court or conducting business in its sparse surroundings. Because of its vibe, many musicians felt freer to experiment and improvise during their performances.

64 West 52nd Street–Lou Richman's Dizzy Club

Another low-key jazz joint, but Dizzy Club had a unique feature: a female bouncer. At 6'2", Lois DeFee was also a burlesque dancer. Though club owners may have hired her as a gimmick, she took her job seriously, kicking more than a few rather shocked men out the door. Her tenure did not last long, though. She was poached by Leon and Eddie's club down the street, where she grew even more popular.

66 West 52nd Street– Famous Door

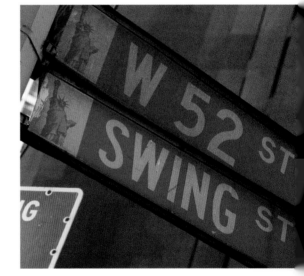

The Famous Door was one of the earlier jazz clubs on the strip, opening its first location here in 1935. Swing and bebop were its specialties. It got its name from the inside door, which famous musicians and celebrity patrons autographed.

Count Basie performed for radio broadcasts on CBS here, helping solidify his stardom. Things didn't go as well for Dizzy Gillespie at the Famous Door. While he was playing with Benny Carter's band, the management asked Carter to fire Gillespie. Apparently, they didn't appreciate his freestyling sounds, complaining he was just hitting bad notes.

21 West 52nd Street-21 Club

Not only is the 21 Club build-
ing the last remnant of Swing
Street, but it was also per-
haps its most famous. Though
not a jazz club, 21 was iconic.
It started out as a speakeasy
in Greenwich Village in 1922,
and became one of the most
famed restaurants in Amer-
ica. Primarily specializing in
American cuisine, 21 was also
known for its old men's club
appearance. Its list of patrons
is amazing: Mae West, Al
Jolson, Judy Garland, Ernest
Hemingway, and Marilyn
Monroe. All but one presi-
dent, Barack Obama, have
eaten there since it opened
on 52nd Street in 1930. Sadly
it closed in 2020.

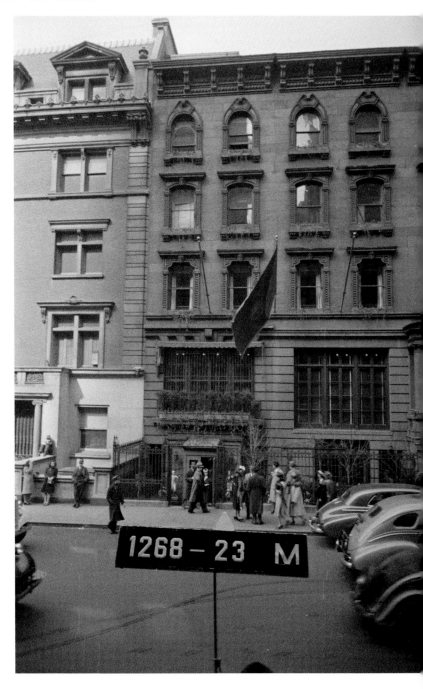

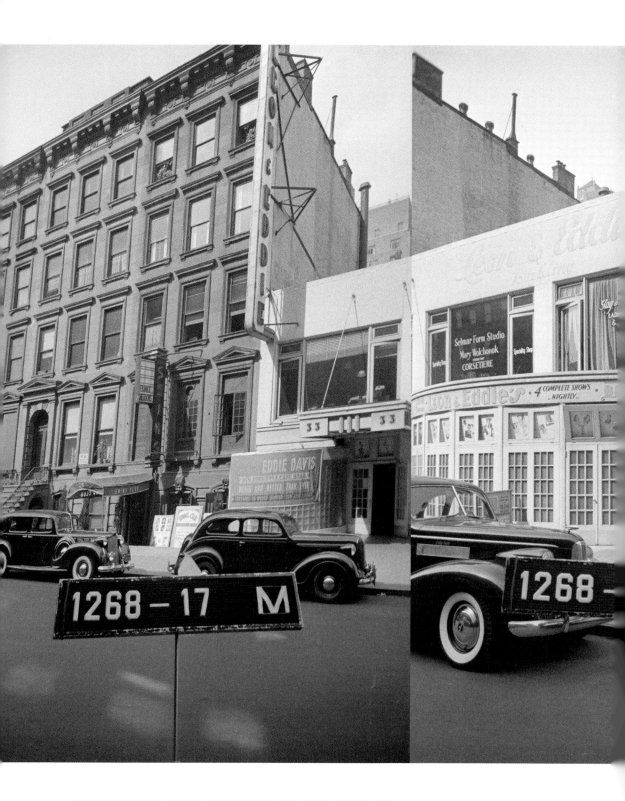

33 West 52nd Street– Leon and Eddie's

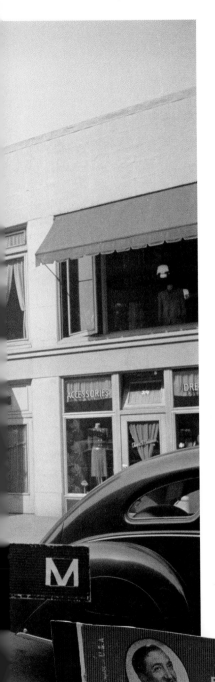

Even though it was one of the best-known clubs on 52nd Street, Leon and Eddie's was more of a nightclub than a jazz club. They hosted various musical performers, comics, burlesque acts, and even animal acts. Jackie Gleason, Jerry Lewis, Dean Martin, and Milton Berle all performed there. The owners took pride in knowing regulars by their first names, sending thousands of birthday cards to repeat customers.

11 West 53rd Street–Museum of Modern Art

This 1930s photograph further illustrates the unrestricted modernism the Museum of Modern Art brought when it was built with great fanfare in 1939. Not only is it a startling contrast to the traditional brownstones that dotted the neighborhood, but it was also a symbol of the style and sophistication Midtown Manhattan was about to undergo. Designed by architects Philip L. Goodwin and Edward Durell Stone, they pushed modern building materials and design in its construction. In recent years, the MOMA has been expanded and renovated, but the building still nods to its earlier incarnation.

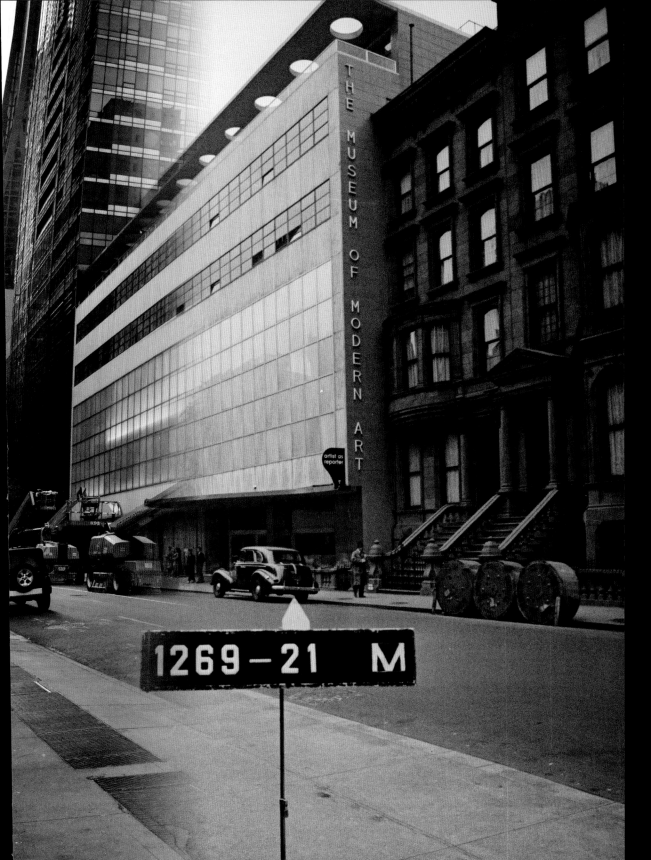

1462-1470 Broadway– Knickerbocker Hotel

One of the crown jewels in the otherwise gaudy, fast, ever-changing Times Square is the Knickerbocker Hotel. This grand dame of the French Renaissance style has been holding court at the corner of 42nd and Broadway since 1906.

The Knickerbocker was once one of the centers of the New York City social scene. In fact, the hotel bar earned the nickname "The 42nd Street Country Club." Singer and composer George M. Cohan and operatic tenor Enrico Caruso were both longtime residents. And it was here that executives from the Boston Red Sox found out they were losing Babe Ruth to the New York Yankees.

Today, renovated and restored to its former glory, it also has the distinction of being listed on the National Registry of Historic Places.

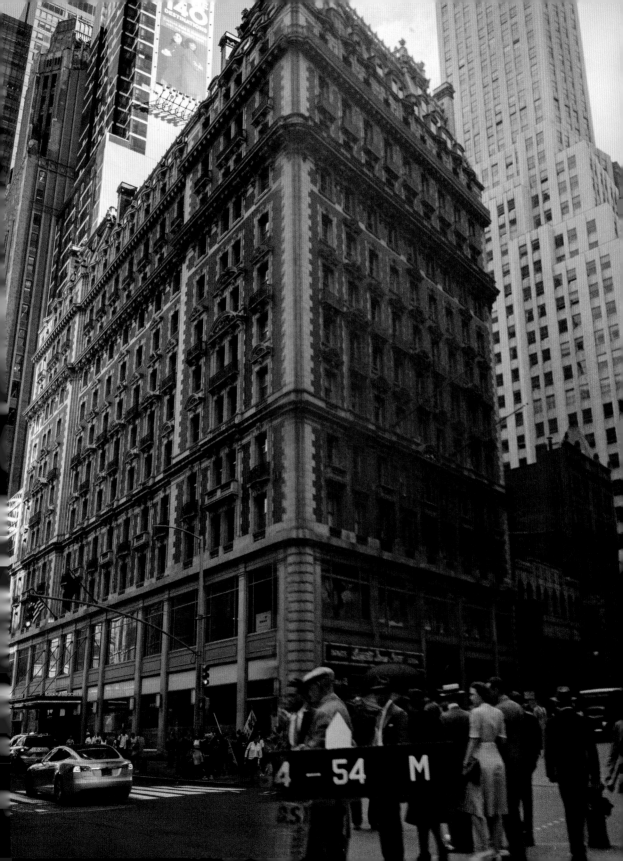

147 East 41st Street– Jack Doyle's Billiard Academy

As one can imagine, this second-floor pool hall had colorful clientele. It was popular with the theater and sports crowds, news reporters, and small-time crooks.

Opened by Jack Doyle and Yankees manager John McGraw in 1907, it was more than just a run-of-the-mill pool hall. Jack Doyle's held major tournaments—including ones for the ladies—during its heyday in the 1930s.

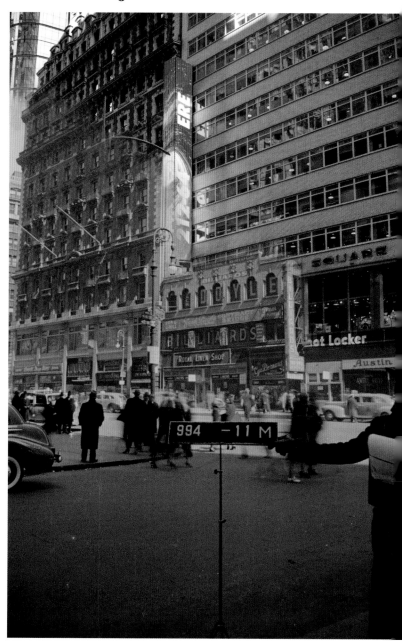

214 West 42nd Street–
New Amsterdam Theatre

Built in 1903, the New Amsterdam Theatre is one of the oldest in Times Square and more recently helped usher in Times Square's revitalization in the 1990s. Architects Henry Herts and Hugh Tallant designed it in a Beaux-Arts and Art Nouveau design. Past performers include Will Rogers, W. C. Fields, Fanny Brice, Eddie Cantor, and the Ziegfeld Follies. After a slow degradation over the decades, with the theater showing unsavory movies, it was shuttered in 1985.

In 1995, the Walt Disney Company purchased the New Amsterdam and restored it as a theater for live productions such as *The Lion King* and *Mary Poppins*. Disney's investment paid off and helped bring in other big-name corporations, which reenergized the district.

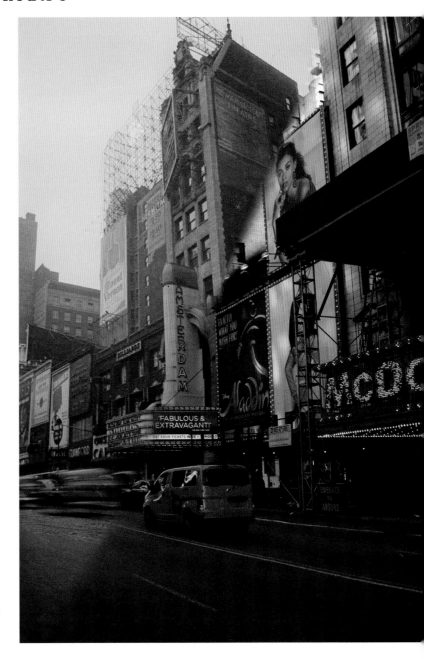

1514-30 Broadway–
Bond International Casino

The International Casino contained a nightclub, a theater, and various shops at the corner of Broadway and 44th. Opened in 1930, it never quite lived up to its hype, and after a few years, Bond Clothing Store took over the space until 1977. During the 1980s, the space became a music venue hosting a number of punk bands including The Clash, Blondie, and the rock group Blue Öyster Cult.

In 1936, the lighted billboard for Wrigley's Spearmint gum was touted as the largest of its kind in the world. The underwater theme, featured animated fish along with Wrigley's elf mascot. The sign used over 1,000 feet of tubing, almost 3,000 lamps, and some 70 miles of wire, and it cost a then-astronomical $1 million.

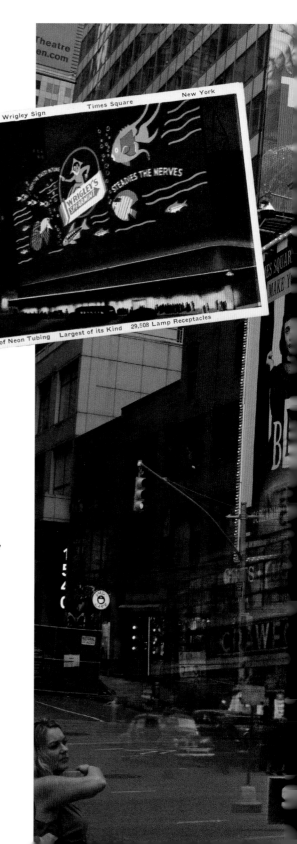

234

Wrigley Sign Times Square New York

WRIGLEY'S SPEARMINT STEADIES THE NERVES

1084 Ft. of Neon Tubing Largest of its Kind 29,508 Lamp Receptacles

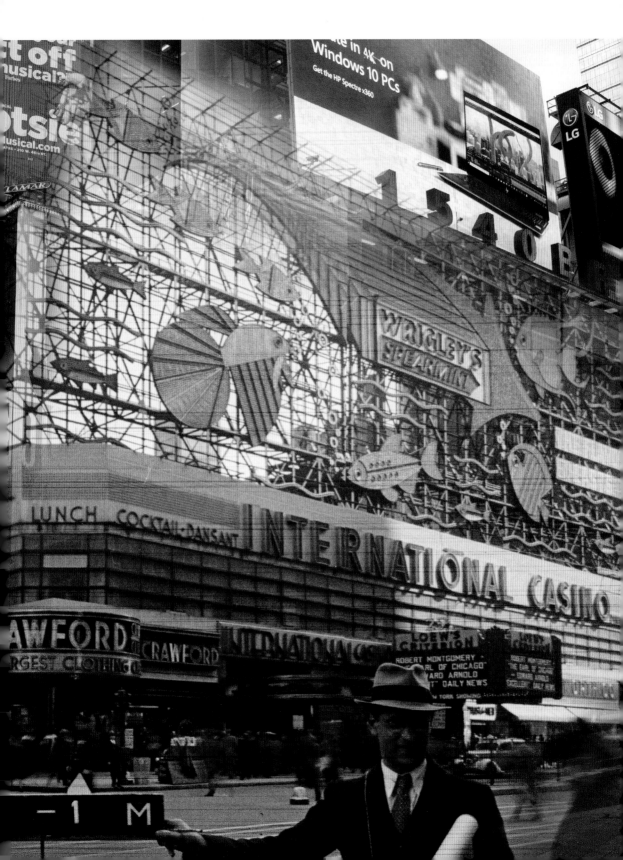

200 West 47th Street-Patrick Duffy Square

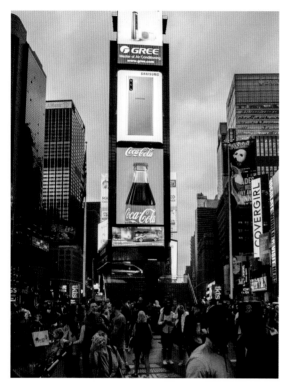 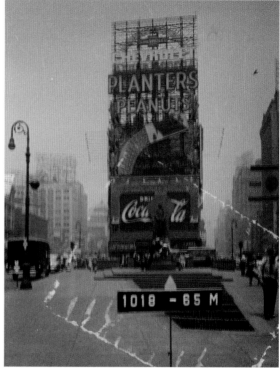

Though most of what is pictured on this small parcel of Times Square is gone, Patrick Duffy Square is still one of the most recognizable spots in the neighborhood. The previous building housed various offices, many catering to the entertainment business. However, it's the signage completely draping the building that takes center stage. In fact, making the signage even more extraordinary was key when a new office building was constructed here in 2008. Neon and light bulbs were replaced with video screens and fiber optics. Incidentally, Coca-Cola still holds a spot here, having done so for decades.

Duffy Square is named after Chaplain Francis P. Duffy, honored for his service in the Spanish-American War and during World War I. Duffy is credited with saving dozens of wounded soldiers. As a result, he is the U.S. Army's most decorated chaplain. Right behind his statue sits the innovative TKTS Discount Booth, which offers day-of-show tickets at deep discounts. The booth is designed so that visitors can sit on lighted red bleachers on its roof and take in all of Times Square.

149 West 45th Street-Lyceum Theater

Opened in 1903, this theater is not only one of the oldest on Broadway, but it has been continuously operating longer than any other theater in the district. Its Beaux-Arts style design makes it one of the most elaborate looking theaters on Broadway. Notable productions include *The Importance of Being Earnest*, *The Postman Always Rings Twice*, and *Liza with a Z*.

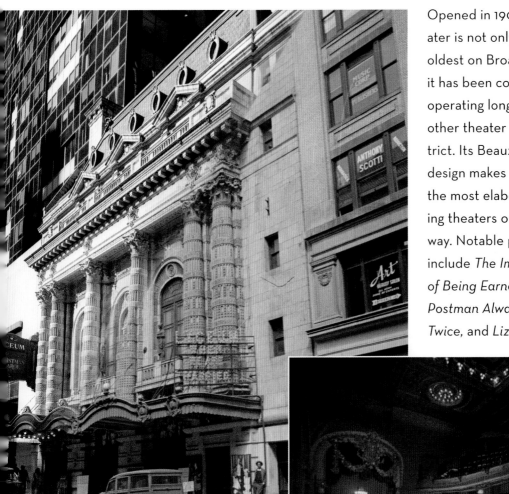

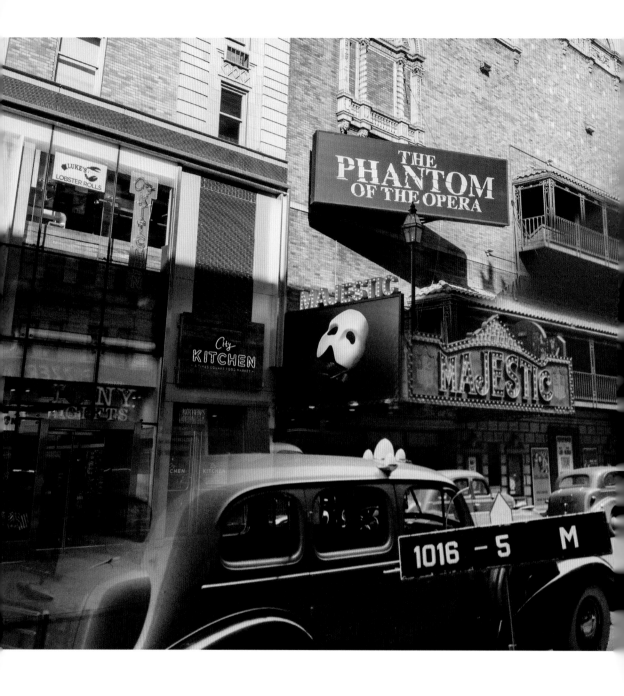

245 West 44th Street–
Majestic Theater

Built in 1927, the Majestic Theater is one of the largest Broadway theaters having 1,681 seats.

Well-known musicals played here, including *Hellzapoppin, The Music Man,* and *Camelot*. Its most successful production was *Phantom of the Opera*. with over 13,000 performances and over 1 billion dollars in ticket sales.

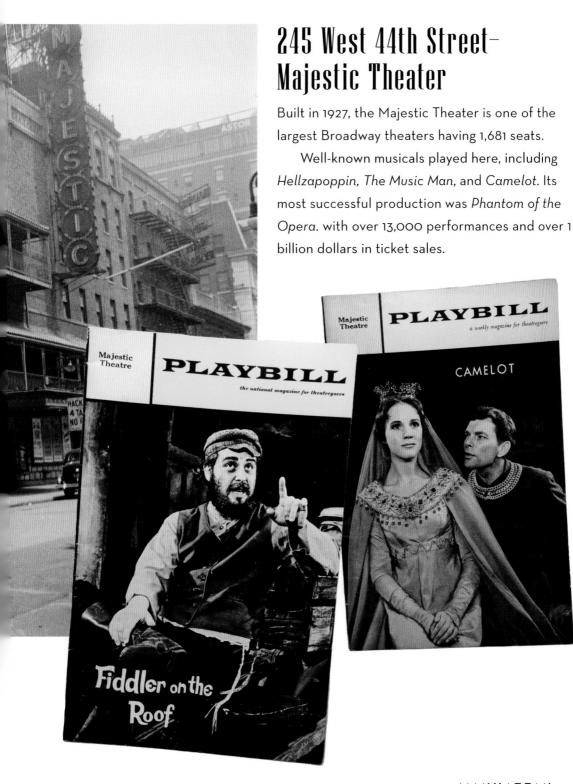

234 West 44th Street-Sardi's

This is the most famous restaurant in the theater district—and for good reason. Since 1927, Sardi's has catered not only to theatergoers but to the performers of the shows. Sardi's has an amazing collection of hand-drawn caricatures of Broadway performers from throughout the decades. The tradition started when Mr. Sardi first offered artist Alex Gard a free meal for every piece he drew for the restaurant. There are 1,300 currently adorning the walls. Today, having your likeness displayed here is akin to getting a star on the Hollywood Walk of Fame.

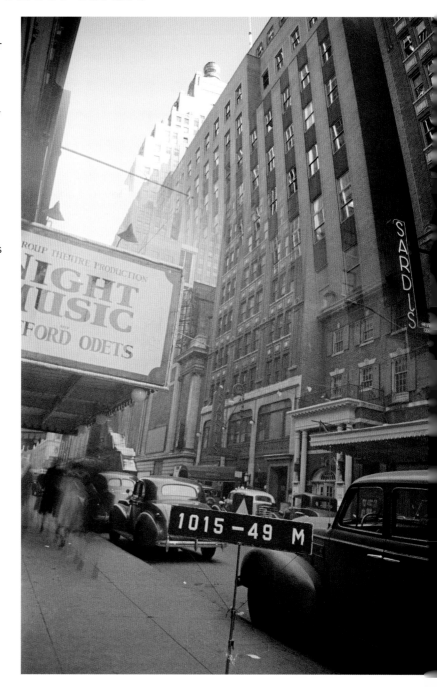

228 West 52nd Street– Gallagher's Steakhouse

Another theater crowd mainstay, Gallagher's is a quintessential New York City steakhouse dating all the way back to 1927. Vaudeville performer Ed Gallagher and his wife, Ziegfeld girl Helen Gallagher, along with gambler Jack Solomon opened the place first as a speakeasy. Just two years later, Mr. Gallagher passed away and Helen and Jack got married. They continued running Gallagher's together until Helen's passing in 1943.

The steakhouse can lay claim to being the first place to serve a *New York strip*—a premium cut of beef located on the loin.

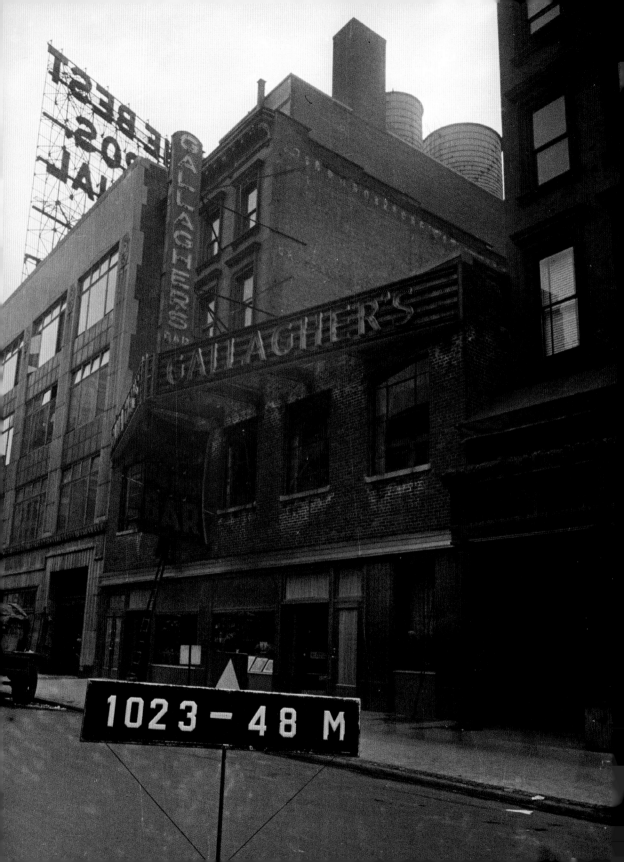

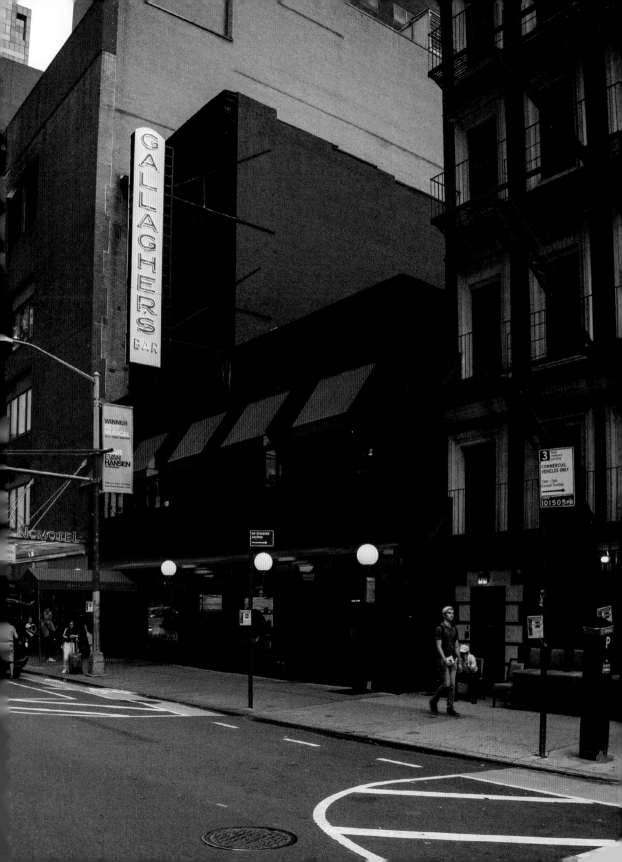

224-228 West 47th Street–Hotel Edison

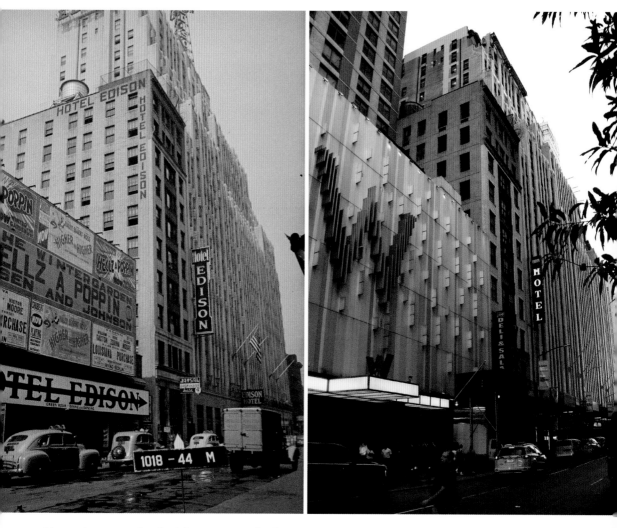

Along this stretch of addresses sits the historic Hotel Edison. Opened in 1931, its namesake, inventor Thomas Edison, was there to ceremoniously turn on the lights on opening day.

226 West 46th Street– Richard Rodgers Theatre

The Richard Rodgers Theatre can boast hosting the most Tony Award winning shows: eleven winners, including *Damn Yankees*, *How to Succeed in Business Without Really Trying*, *Chicago*, and, most recently, *Hamilton*. Built by real estate mogul Irwin Chanin in 1925, it was originally named Chanin's 46th Street Theatre but was changed to honor composer Richard Rodgers in 1990.

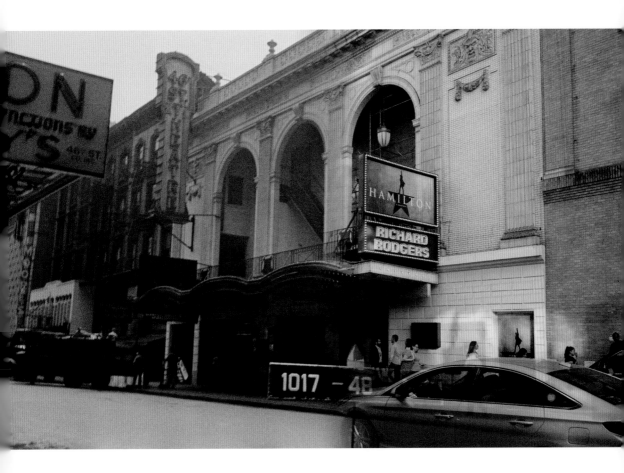

1697 Broadway–Ed Sullivan Theater

Now home to *The Late Show with Steven Colbert,* 1697 Broadway has had its share of cultural touchstones over the years. It started out as Hammerstein's Theater, named after its owner, Oscar, who was a playwright and father of songwriter Arthur Hammerstein. It was built in 1927, and one of the first actors to grace its stage was a young Cary Grant.

In 1936 a long relationship began with the Columbia Broadcasting System that still exists today. Over the years, it went by several names, including Radio Theater #3, CBS Radio Playhouse, and then CBS-TV Studio 50. The Television Age saw the theater hosting classics such as $10,000 *Pyramid, What's My Line?, The Jackie Gleason Show,* and *The Ed Sullivan Show.* On February 9, 1964, America was famously introduced to that band from Liverpool, The Beatles, changing pop culture forever. In 1993, CBS finally bought the theater so talk show host David Letterman could produce his show there, which he did until 2015.

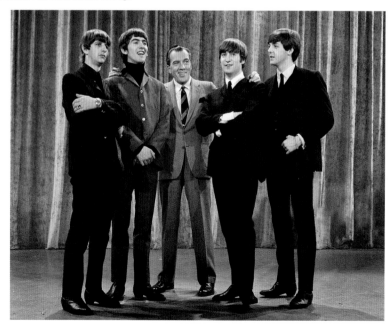

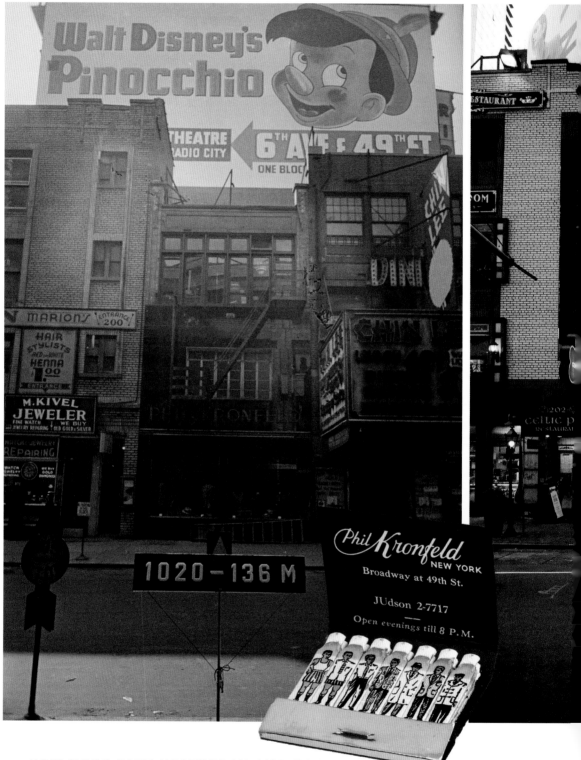

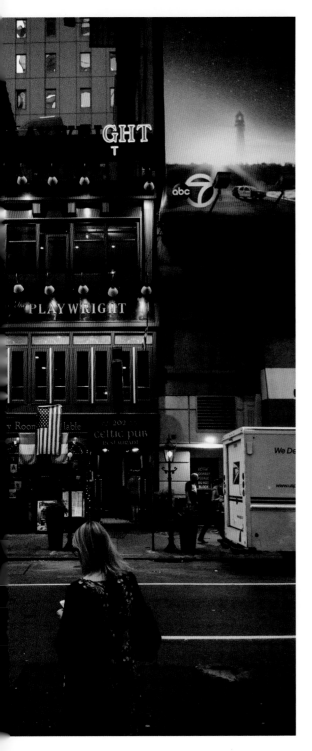

202 West 49th Street– Phil Kronfeld

It's easy to forget that Times Square is a place not only for entertainment but also for retail. This is the famed Phil Kronfeld haberdashery. With another location on the Lower East Side, it was considered the height of men's fashion. Performers and well-heeled businessmen would buy the styles of the day, like sharkskin suits and men's suit jackets that dared to go against convention by having only one button. The haberdashery closed in the late 1980s. Since 1995, the building has been the Playwright Pub, featuring mainly Irish/English dishes.

To the right of Phil Kronfeld's is the Chin Lee Restaurant and nightclub, part of the 1940s chop suey craze. They offered a huge menu, with dinners around 70 cents. Quite a bargain, considering there was a live orchestra and dance floor too. And note the billboard above. Would passersby have had any idea what a beloved film *Pinocchio* would become around the world? Or how Disney would lead the way for the revitalization of Times Square some 55 years later?

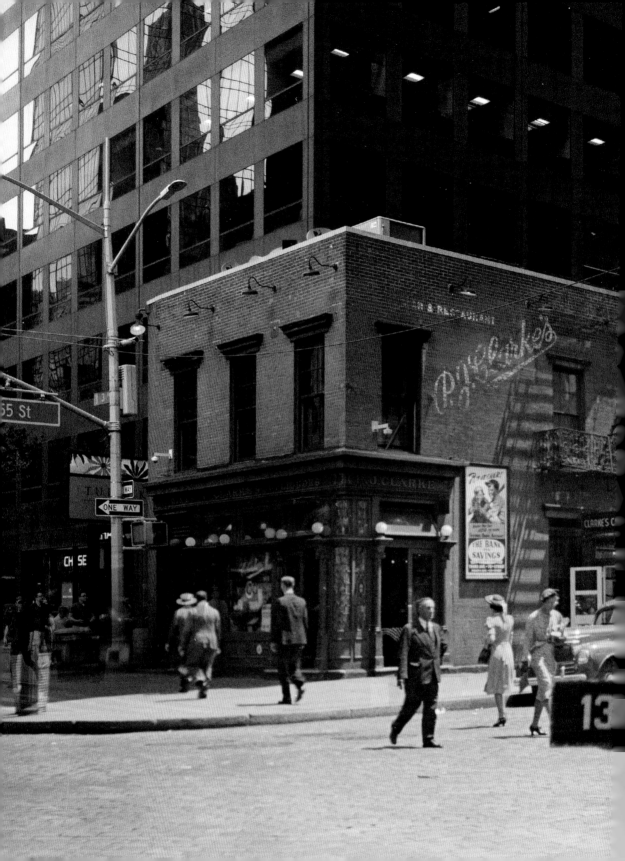

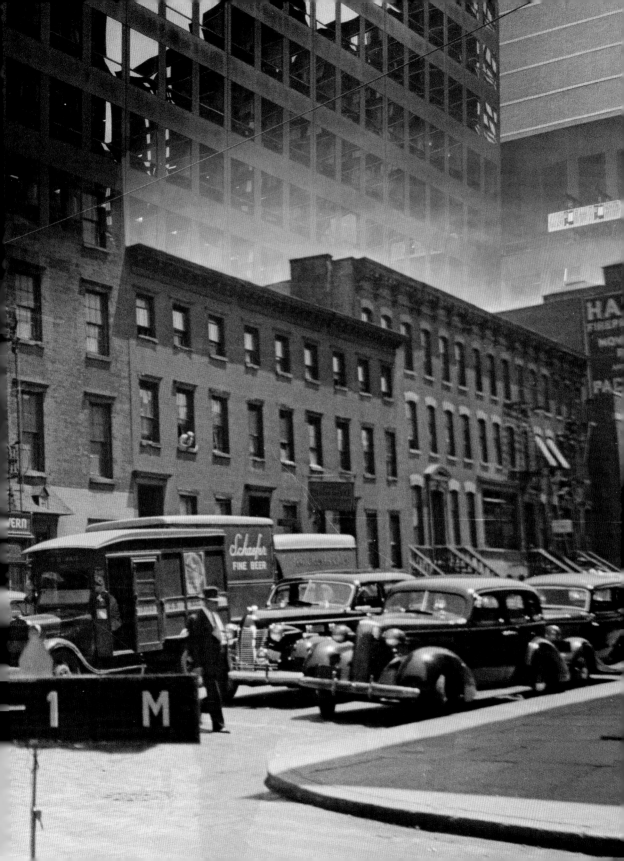

915 Third Avenue– P. J. Clarke's

Opened in 1884, P. J. Clarke's is one of the oldest restaurants in America and one of the few bastions of Old New York left in Midtown Manhattan. The near-original saloon is now dwarfed by skyscrapers and office towers. Its interior is packed with vintage decor with equally interesting stories to go with it. For instance, there is the dog named Skippy, who used to hang around the bar in the 1930s until he was hit by a car. Bar patrons took up a collection to have him stuffed and he resides on a shelf there to this day.

P. J. Clarke's regulars included Nat King Cole, Jacqueline Kennedy Onassis, and Frank Sinatra. In fact, songwriter Johnny Mercer wrote the Sinatra hit "One for My Baby" while sitting at the bar.

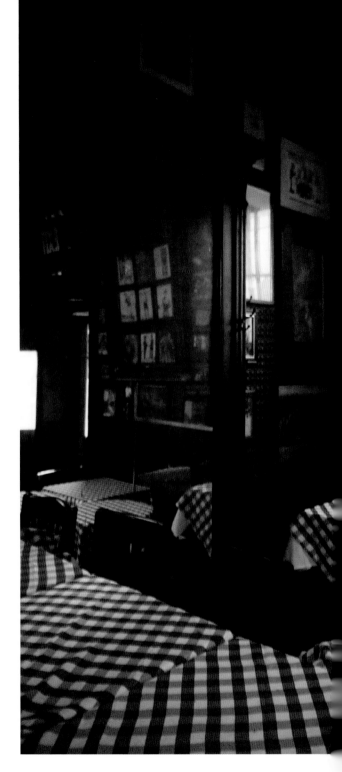

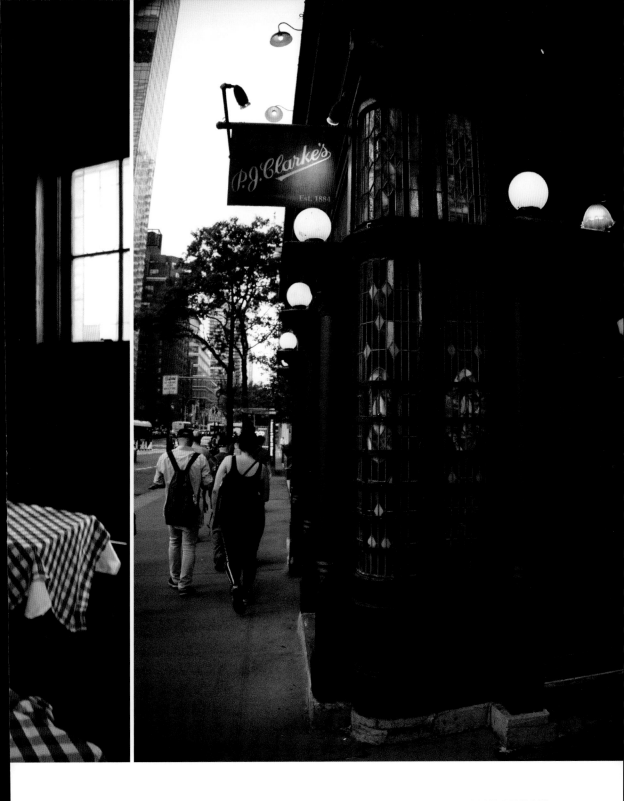

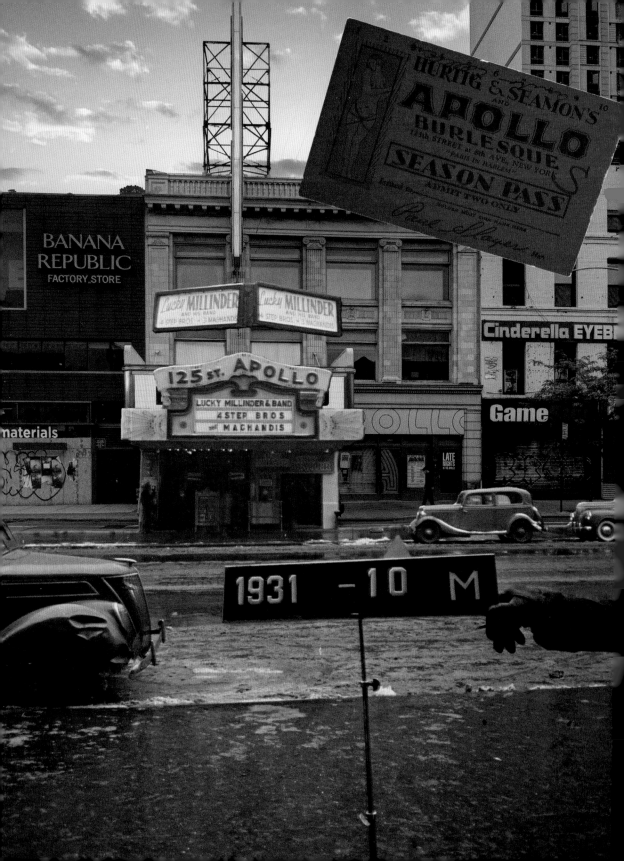

253 West 125th Street– Apollo Theater

When this photo was taken, the Apollo Theater was already hitting its stride as the premiere place to see nationally famous Black entertainers. Sarah Vaughan, James Brown, Ella Fitzgerald, and Luther Vandross are just a tiny sampling of performers here. Sidney Poitier even starred in his first dramatic play at the Apollo.

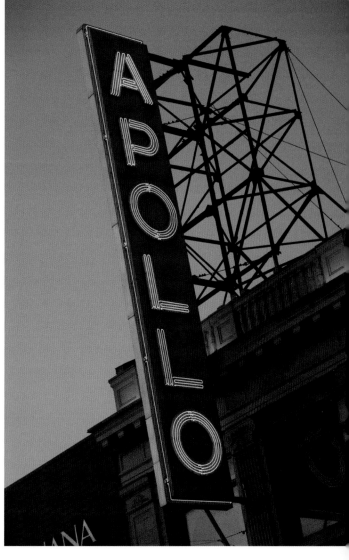

The Apollo's Amateur Nights are famed. They started in 1934, and Ella Fitzgerald, Pearl Bailey, and Jimi Hendrix all won the coveted contest. (But how's this for a surprise? James Brown and Dionne Warwick lost!)

The theater was designed in a Neo-classical style with just over 1,500 seats. Opened in 1914, it was originally Hurtig and Seamon's New Burlesque Theater. Ironically, Black people were not allowed to attend or perform.

In 1934, it was renamed the Apollo and began catering to a Black audience. Comedians and musicians playing jazz, R&B, doo-wop, soul, funk, hip-hop . . . all are honored to perform at this venue. Rock bands revere the place too. Guns N' Roses and Duran Duran are among the many who have played here.

Brooklyn

333-339 2nd Street

Just a few of these buildings remain, but to this day, the Park Slope neighborhood is popular with families, as this photo can attest to. Some of the best-preserved 19th-century brownstones and mansions are in Park Slope.

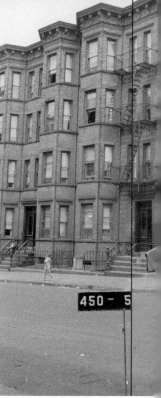

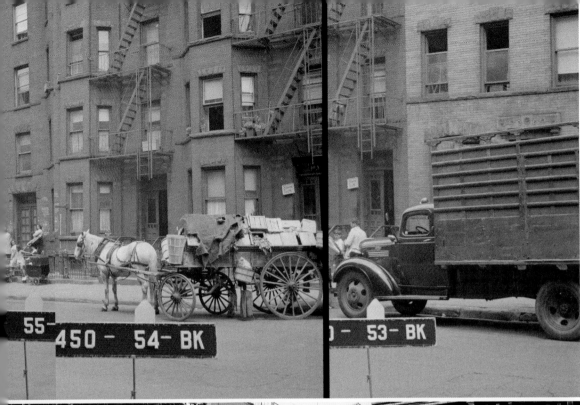

55- 450 - 54- BK

0 - 53- BK

319 4th Avenue-Tire Shop

This pair of photographs illustrates the incredible amount of gentrification that has taken place throughout Brooklyn. 319 4th Avenue runs through Gowanus, a neighborhood known for the infamous canal located near 3rd Avenue. Just a few decades ago, the canal was known as one of the dirtiest bodies of water in America, due in part to being in an industrial area with little regulation. Today, the canal has been cleaned up enough for wildlife like beavers and ducks to call it home. As for the building at 319 4th Avenue, it too has undergone a spit shine: Rather than a tire shop and bar, it houses a hair salon, dance studio, and music academy.

535 East 141st Street-Ebbets Field

This is one of the most recognizable ballparks in America, but not even a fragment of it exists here now. Following along Bedford Avenue and Sullivan Place, Ebbets Field's footprint is now filled mostly with housing units.

Built in 1913 and costing an unheard of $750,000, Ebbets Field was immediately revered by Dodgers fans and Brooklynites alike. There are still a few old-timers around to remember the two most important days in Ebbets Field history. On April 15, 1947, Jackie Robinson took the field, breaking the color barrier in baseball. Then on October 4, 1955, the Dodgers won the World Series against the mighty New York Yankees. But in 1958, owner Walter O'Malley did the unthinkable and moved the team to Los Angeles. Ebbets was torn down two years later.

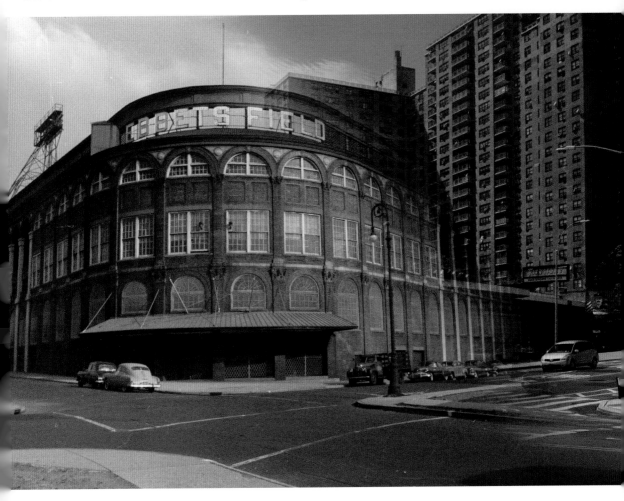

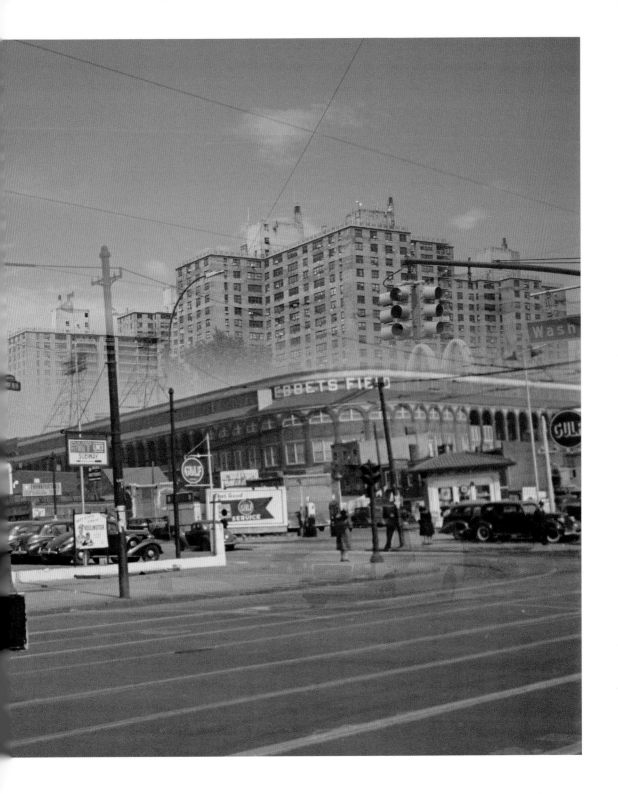

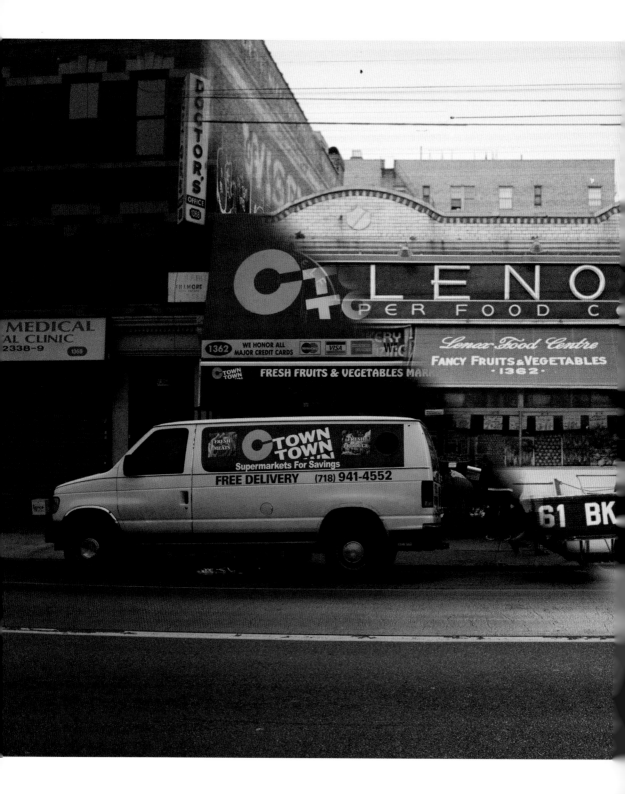

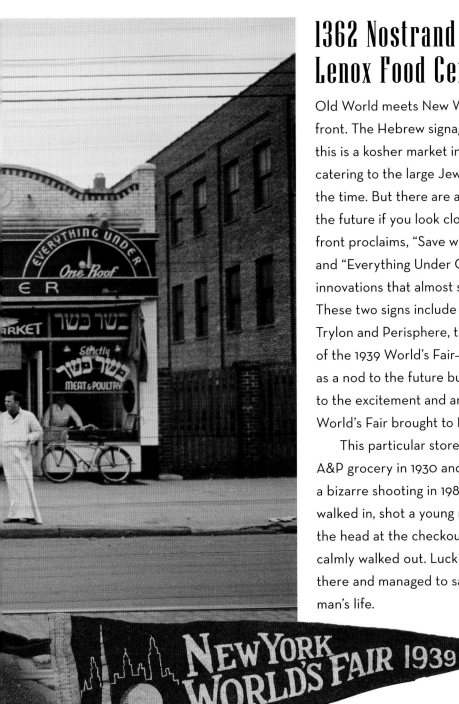

1362 Nostrand Avenue–Lenox Food Center

Old World meets New World in this storefront. The Hebrew signage clearly states this is a kosher market in East Flatbush, catering to the large Jewish population at the time. But there are also flourishes of the future if you look closely. The storefront proclaims, "Save with Self Service" and "Everything Under One Roof," two innovations that almost seem quaint today. These two signs include depictions of the Trylon and Perisphere, the official symbol of the 1939 World's Fair—perhaps put there as a nod to the future but also testament to the excitement and anticipation that the World's Fair brought to New York City.

This particular store started as an A&P grocery in 1930 and was the scene of a bizarre shooting in 1984. A man calmly walked in, shot a young man point blank in the head at the checkout lane, and then calmly walked out. Luckily, a doctor was there and managed to save the young man's life.

1050 Nostrand Avenue

Most likely depicting an Italian-American parade, this series of photos serves as a reminder of the hometown feeling in many Brooklyn neighborhoods of the time. Nostrand Avenue in Prospect Lefferts Gardens has been a major throughway in Brooklyn for eons, running 8 miles through several neighborhoods. To this day, dozens of mom-and-pop stores dot the avenue, catering to immigrants from around the world.

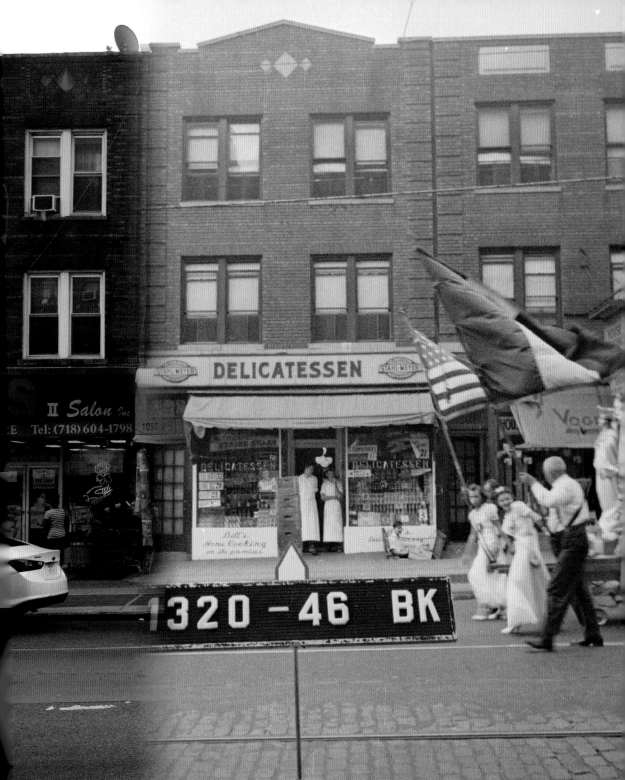

1697 East New York Avenue–Italian Groceries

Not much is known about this small grocery store, but it attests to the once large presence of Italian-Americans in the Crown Heights neighborhood. The horse and wagon may be delivering perishables that could not be shipped from afar. Deliveries and pickups by horse were still quite common in New York City when this photo was taken.

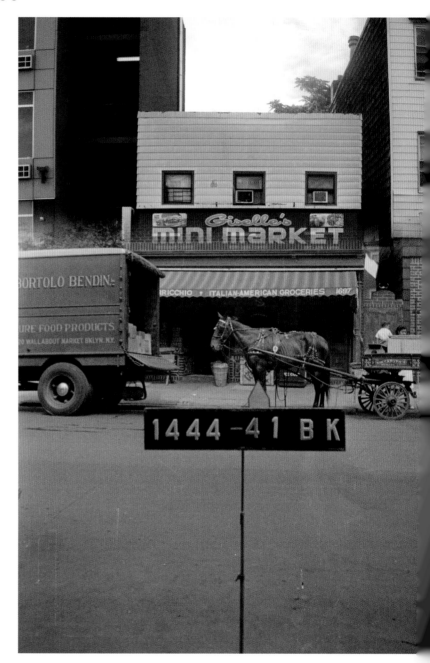

1302-10 Surf Avenue-Nathan's Famous Coney Island

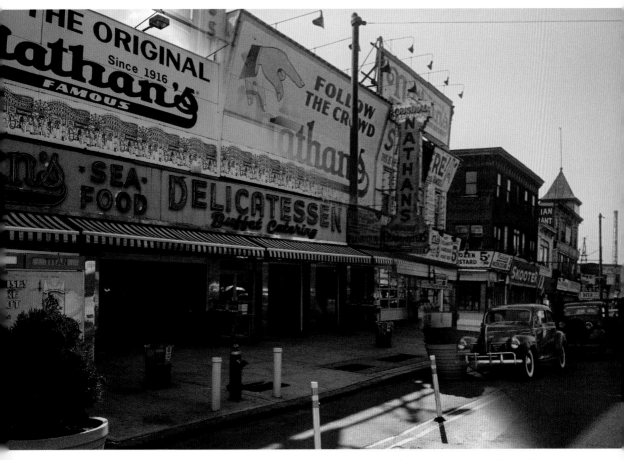

This is one of the most recognizable landmarks in Coney Island. Since 1916, Nathan's Famous has been serving up hot dogs along with fries, milkshakes, seafood, chicken, and even frog legs. Though the hot dog was not invented here, Coney Island helped popularize it, and Nathan's is clearly its ambassador.

The place opened with a $300 loan that Polish immigrant Nathan Handwerker received from his friends. He had two tricks up his sleeve: His wife's secret hot dog spice recipe and the plan to charge 5 cents per hot dog, half the going price. Other gimmicks included having his workers wear surgical smocks to offset the common belief that hot dogs were made in less-than-sanitary conditions. Al Capone and Franklin Roosevelt were among Nathan's famous customers, and actress Clara Bow worked here before she became famous.

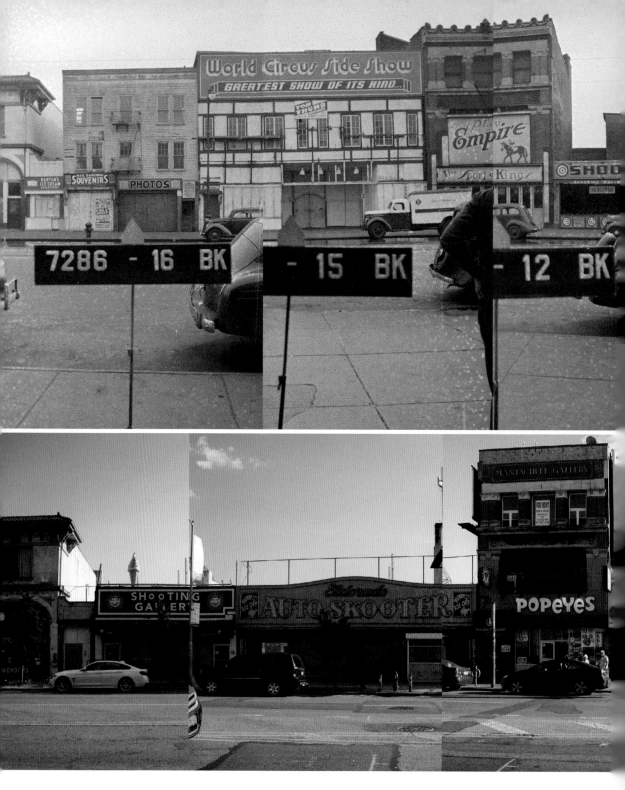

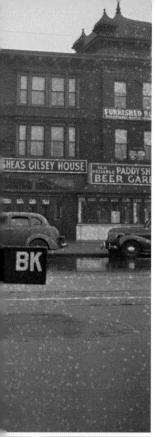

1208 Surf Avenue–Child's Restaurant

This was another Child's Restaurant location in New York City. At one time, there were over 90. Today this building enjoys landmark preservation status.

Today it houses Coney Island USA, a nonprofit dedicated to the revitalization of Coney Island. It's also home to a museum and a classic sideshow.

1216 Surf Avenue–
World Circus Side Show

This establishment gave Coney Island its own quintessential sideshow in the vein of traveling country carnivals and P. T. Barnum. Created by "Professor" Samuel Wagner, the World Circus Side Show had a long life, operating from 1922 to 1941.

Many of the stars at World Circus Side Show are known even today, including Pip and Zip (the Pinheads), Prince Randian (the Human Torso), and Lady Olga (the Bearded Lady). By most accounts, the stars of the show were well treated and well paid, often supporting their families from their sideshow endeavors.

1220 Surf Avenue–
Herman Popper Building

Built in 1904, this Renaissance Revival building's namesake was Herman Popper who was a liquor distributor. Perhaps not surprisingly, the first floor housed a series of game rooms that were often raided on suspicion of illegal gambling.

1102-1110 Surf Avenue

Over the years, this stretch of buildings housed game rooms, souvenir shops, and eating establishments. They are some of the oldest buildings left in Coney Island.

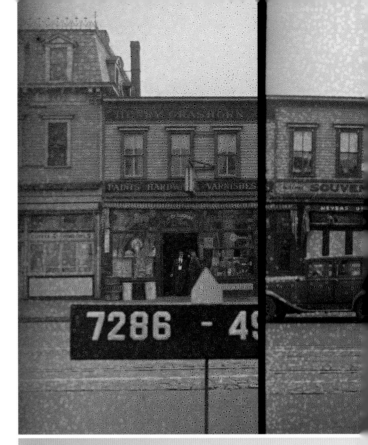

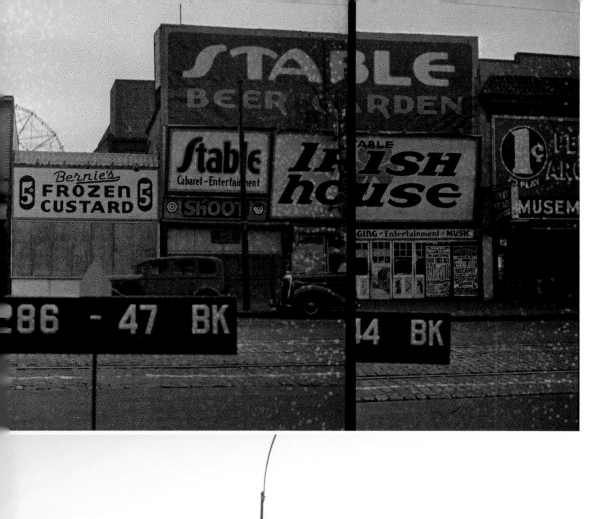

1524 Neptune Avenue– Totonno's Pizzeria

This unassuming pizza place has a serious pedigree. Opened in 1924, it's the oldest continually family-owned pizzeria in America. It was started by Anthony Totonno, who emigrated from Italy in 1903. His grandchildren now run the place.

Pizzas are made here just like they were in 1924 with a coal-fired oven. As part of their legacy, they are one of the few New York City restaurants with special permission to use coal today.

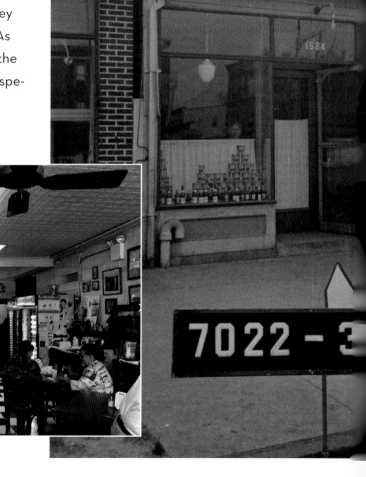

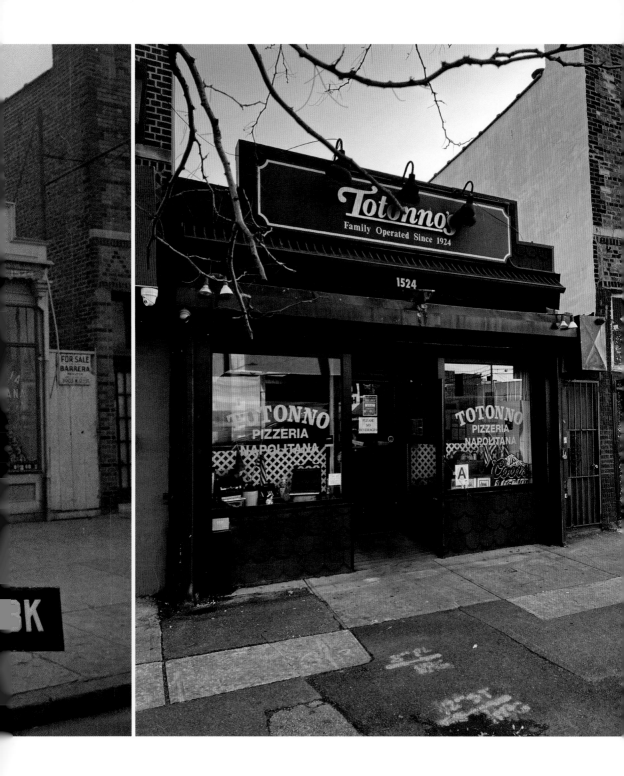

7072-12 Boardwalk West

Coney Island's boardwalk is perhaps the most famous in the world. Formally completed in 1923, the boardwalk spans some 2.7 miles along the Atlantic Ocean. It was built to unify the neighborhood and to create access to the beachfront, which was often in private hands. Many of the attractions were located on the boardwalk—one of the oldest of its kind in America. After many incarnations and renovations, the boardwalk is now a New York City landmark.

Even today, no one can miss seeing the enormous Parachute Jump Tower. First built for the 1939 New York World's Fair, this steel-framed tower is 250 feet tall and was part of the Steeplechase Amusement Park. The ride consisted of two-person seats that would be lifted to the top and then dropped. A parachute would open, slowing the decent. The ride was shuttered in the 1960s. Plans to restore the ride fell through, but by the 1990s it had become such a part of the landscape that the tower alone was restored. Today it enjoys protection on the National Register of Historic Places.

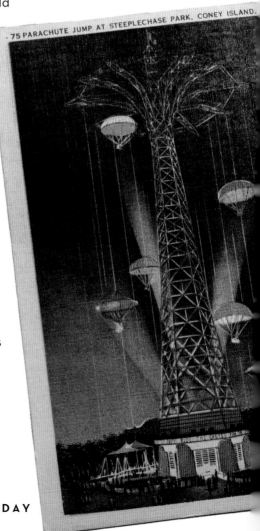

On a side note, check out the store in front of the Parachute Tower. The name reads, "Vas You Dere Charlie," a heavily accented version of "Were you there, Charlie?" This was a popular catchphrase in the 1930s thanks to radio star Jack Pearl. The comedian would take on the persona of Baron Munchausen and tell outlandish stories about his travels, causing his sidekick Charlie to act incredulous. Pearl would then use the catchphrase as a retort.

LETIC FIELD

MAJESTIC BATHS
STEAM ROOMS
ATHLETIC FIELD

5 WELCH'S 5
PURE GRAPE DRINK

ROOMS

GIFT SHOP

VAS YOU DERE
CHARLIE

FREE
RETURN

RA

7072 - 12 BK

48220

1268 Prospect Place

Young and old con-
gregate on this Crown
Heights, Brooklyn
sidewalk. Though now
covered with alumi-
num siding, this row of
1899 houses is hiding
Victorian-era accoutre-
ments underneath. At
the time of this photo,
the neighborhood was
changing from a solidly
middle-class Jewish
neighborhood to an
increasingly diverse
neighborhood.

As for this address,
1268 Prospect Place was
the home to a John W.
Kelly, who lived here with
his parents. On Octo-
ber 4, 1918, he was killed
in action in France serv-
ing with the 307th Infan-
try during World War I.
He was just 22 years old.
It is quite possible the
woman at the front gate
in this photo is his Gold
Star mother.

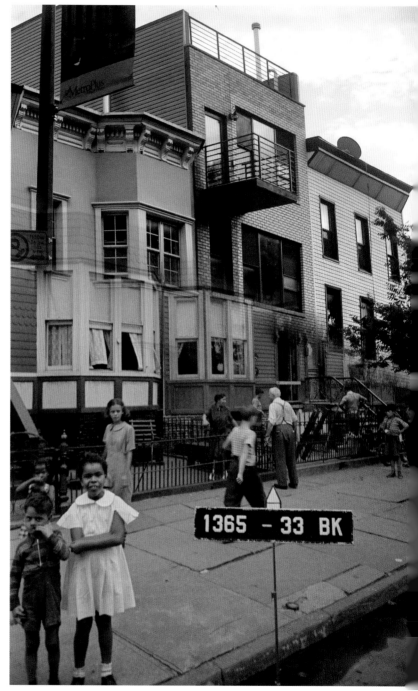

716 Madison Street

The two young ladies are holding a seemingly serious discussion in front of one of the many rows of townhouses that help to give Brooklyn its distinct feel. Located in north-central Brooklyn, the neighborhood of Bedford-Stuyvesant has had both successes and tribulations. Over the decades, it has gone from a fashionable upper-middle-class district to one of the most dangerous neighborhoods in the city. It is now undergoing massive gentrification. Bed-Stuy, as it's nicknamed, can also boast having some of the most original Victorian townhouses in America.

This particular house has witnessed quite a lot of action over the years. In 1930, a suspected gangster's body was found outside here in an automobile. And in 1951, police arrested a man inside the townhouse who was hiding out, allegedly for stabbing a local tavern owner to death.

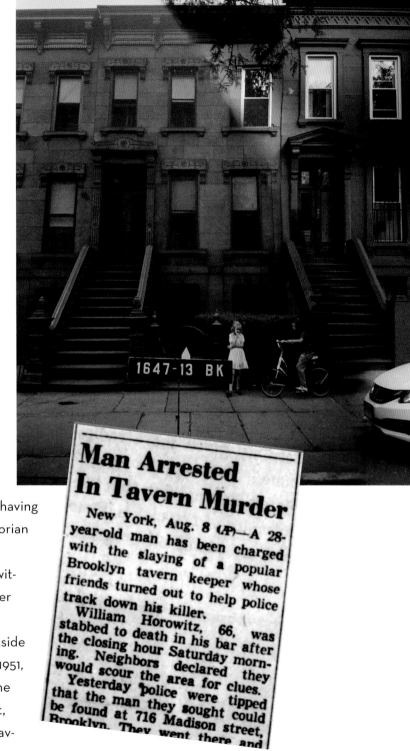

Man Arrested In Tavern Murder

New York, Aug. 8 (AP)—A 28-year-old man has been charged with the slaying of a popular Brooklyn tavern keeper whose friends turned out to help police track down his killer.

William Horowitz, 66, was stabbed to death in his bar after the closing hour Saturday morning. Neighbors declared they would scour the area for clues.

Yesterday police were tipped that the man they sought could be found at 716 Madison street, Brooklyn. They went there and

The Bronx

535 East 141st Street

This spot in Mott Haven was named the People's Park, and not much has changed since this concrete playground was built in 1931. The bevy of young ladies on the corner can be explained by the school located across the street on Brook Avenue.

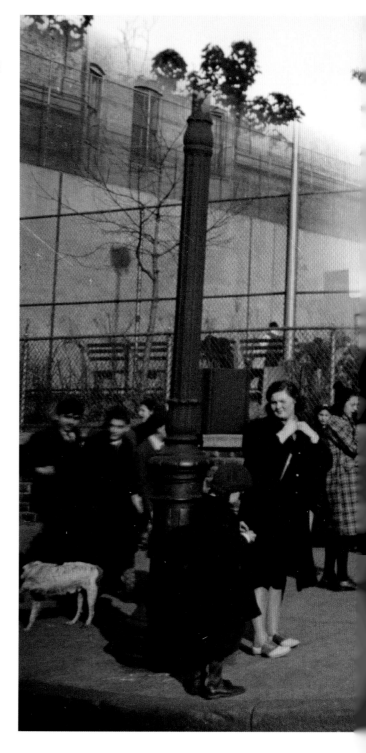

1281 Franklin Avenue

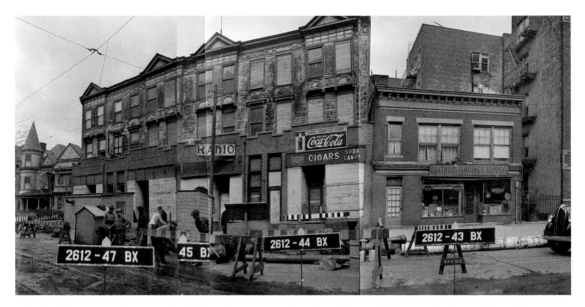

The buildings to the west look like they're on their last leg as laborers look warily at the camera. Indeed, the buildings are all gone, taken up today by a BronxCare Health System Hospital in Morrisania, The Bronx—a not-for-profit teaching hospital.

Today, the building which used to house the Leather & Findings Supply Co. is now the Franklin Avenue Baptist Church. Locals say when this tax photograph was taken, the leather store owner's family lived upstairs above the shop. A common occurrence back in the day.

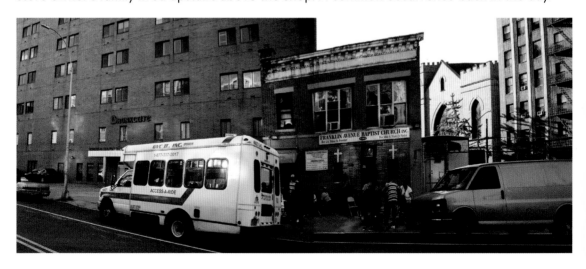

413 East 139th Street

Just one of many 20th-century "photo-bombs" to be found in the tax photograph archives, which evidently were encouraged by the hardworking city photographers.

For decades, the area was an upper-middle-class residential area, mostly serving German-, Irish-, and Italian-Americans. In fact, a group of brownstones on nearby Alexander Avenue was known as "Doctors' Row," and a group on East 134th Street was dubbed "Judges' Row."

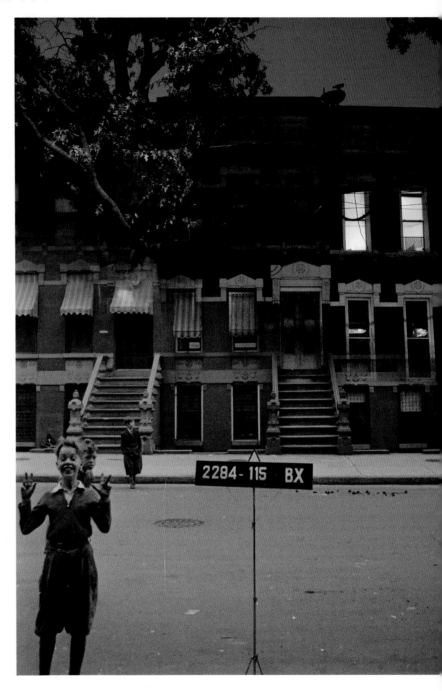

2284-115 BX

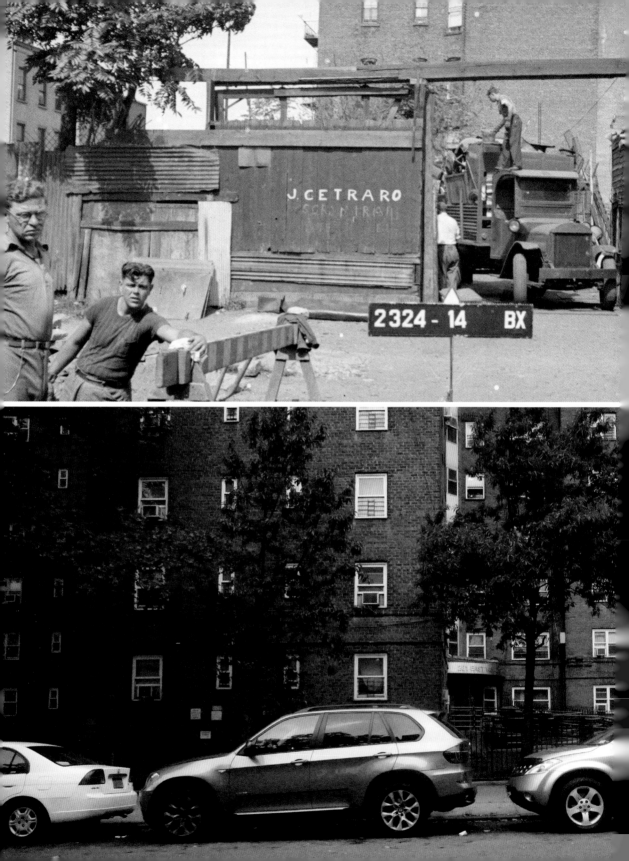

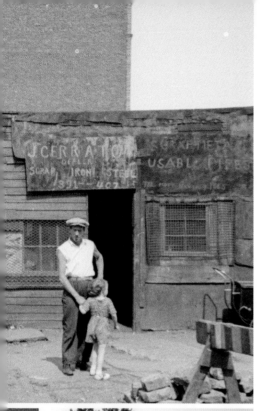

407 College Avenue

Not much is known about this scrap metal business. The building, even this portion of the street, no longer exists. It has been completely replaced by the (Judge) Lester Patterson Houses project in Mott Haven. College Avenue was rerouted and now is part of the neighboring roadways. Built in 1948, the housing project was built primarily for low-income veterans.

475 Saint Ann's Avenue

This little store must have done big business thanks to its location, sitting right across the street from Saint Mary's Park in Mott Haven. Not only has the park been a popular spot for locals since the 19th century, it is also the largest in the South Bronx. Today, this store's former location is now part of a community center.

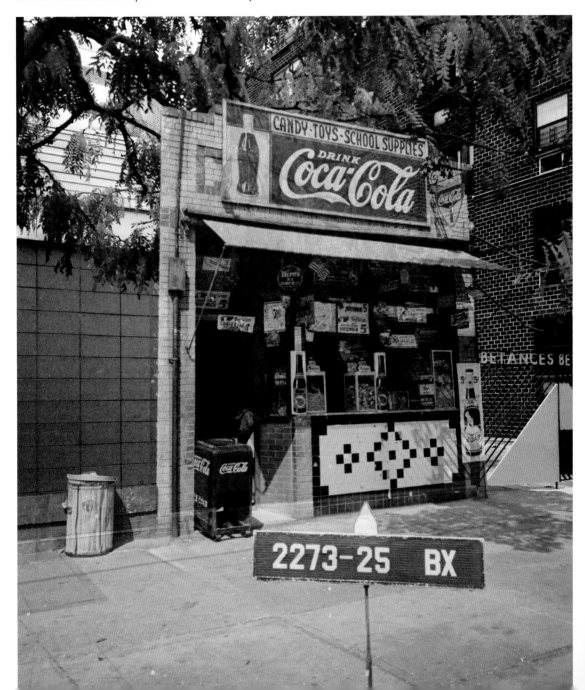

2007 Cornell Avenue (Clason Point)

After its use as a barge, this ship was made land-worthy and became a home. Thanks to more lax city and building regulations back then, structures like this could be more makeshift. For instance, tar paper shacks and even tents were still being used as homes and shops well into the mid-20th century.

This barge is located in Clason Point, a little-known waterfront neighborhood in the Bronx. The area once competed with Coney Island as the city's waterfront playground.

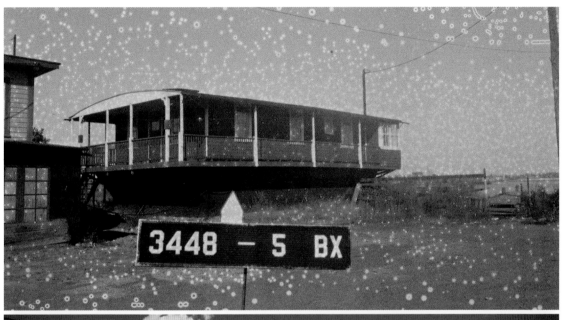

Queens

4101-13 Queens Boulevard

Who says new is always better? Sadly, technology, efficiency, and environmental concerns have left this once-interesting row in Sunnyside, Queens, with vinyl, aluminum, and plastic signs that have the ho-hum appeal of a strip mall.

Still, Sunnyside is one of the more popular bedroom communities in the outer boroughs. Many people feel the neighborhood almost has the trappings of a small town with the convenience of being so close to Manhattan.

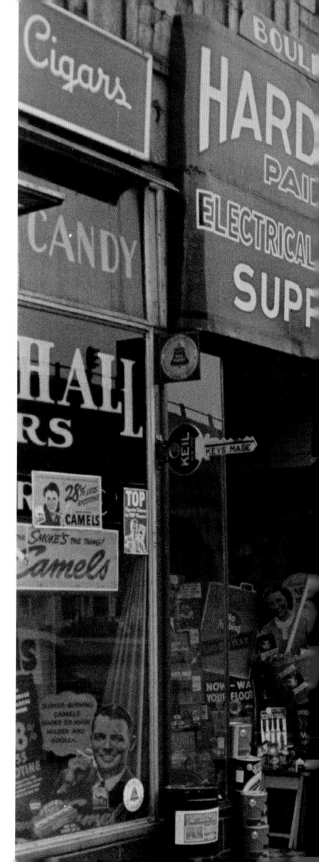

2009 Steinway Street–Ditmars Steinway

The tax photographers seem to have caught quite a busy day on this strip of Steinway Street located in Ditmars-Steinway. The painter looks oblivious to the succession of photos being taken of his work. Not so with the children on the sidewalk, who seem mesmerized if not a little intimidated by the camera.

An interesting side note to Steinway Street and the surrounding neighborhood: It was partially developed by the nearby Steinway and Sons Piano Factory, basically as a company town for its workers. In fact, the factory is still right down the street, having been there since 1880. Today this soda fountain and grocery store are long gone, having been converted into apartments.

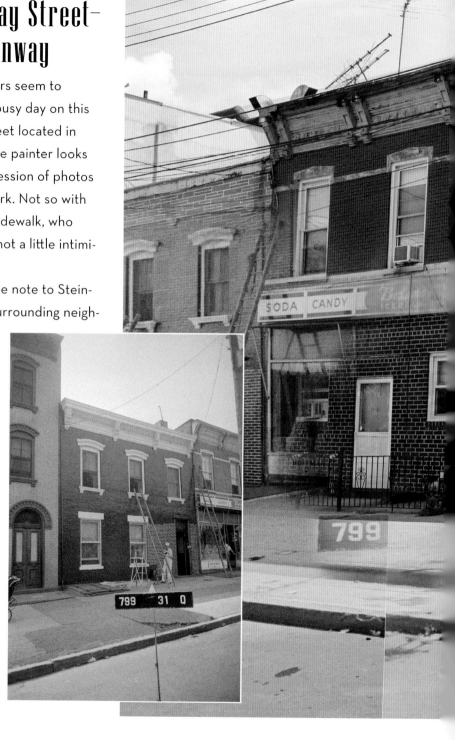

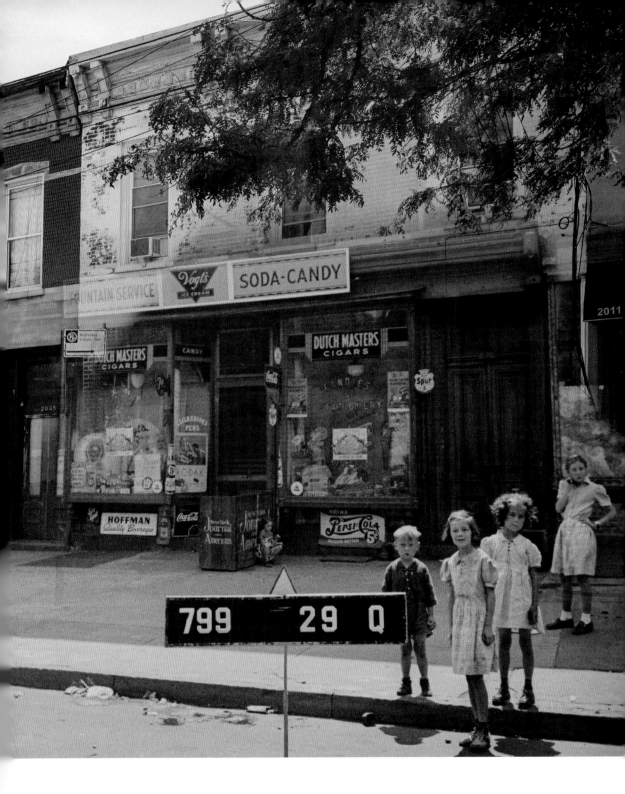

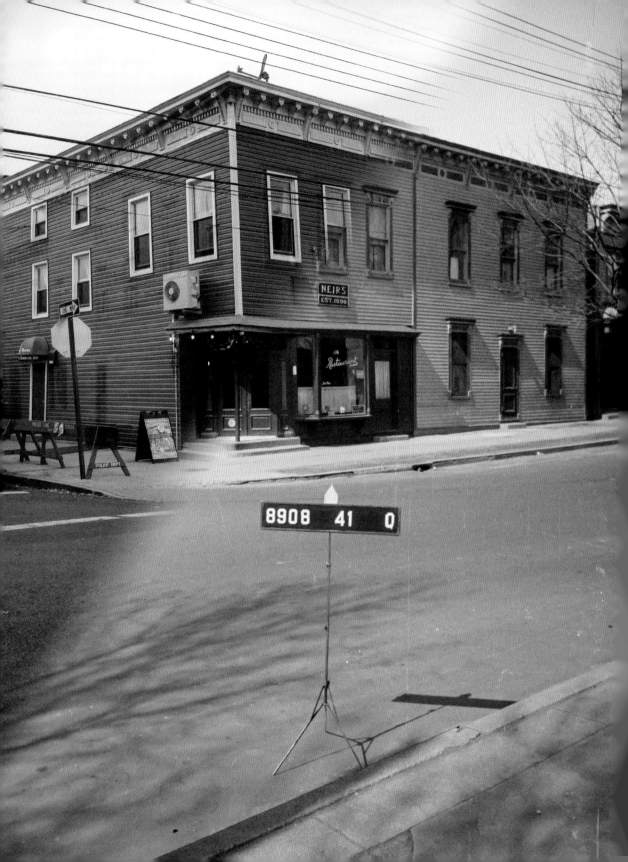

8748 78th Street–Neir's Tavern

One would never guess this unassuming tavern, located on a quiet residential street in Woodhaven, Queens, has been serving customers since possibly 1829. It's the oldest bar in Queens, New York, and one of the oldest in the United States. It was first named the Union Course Tavern after the famed racehorse track that was once across the street. Its patrons were stable boys, jockeys, after-work laborers, and local immigrants.

Upstairs was a hotel, rumored to do double duty as a brothel. Actress Mae West was said to have gotten her start (no *not* upstairs) as a house singer, and even comedian W. C. Fields dropped by a couple of times.

Several scenes from the 1990 film *Goodfellas* were shot there. Amazingly, the inside looks very much the same as it did in the movie.

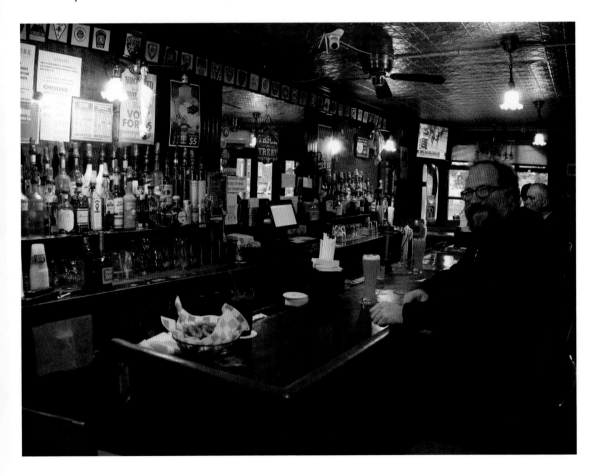

169-20 Jamaica Avenue–Bellitte Bicycles

Bellitte Bicycles has been selling bicycles since 1918, and incredibly, it is still owned by the same family, making it the oldest of its kind in America. In fact, when Mr. Bellitte put his sign up, Jamaica Avenue was not even a paved road yet.

Bellitte was quite the entrepreneur. He started selling bicycles alongside Indian brand motorcycles and another craze just catching on at the time: radios.

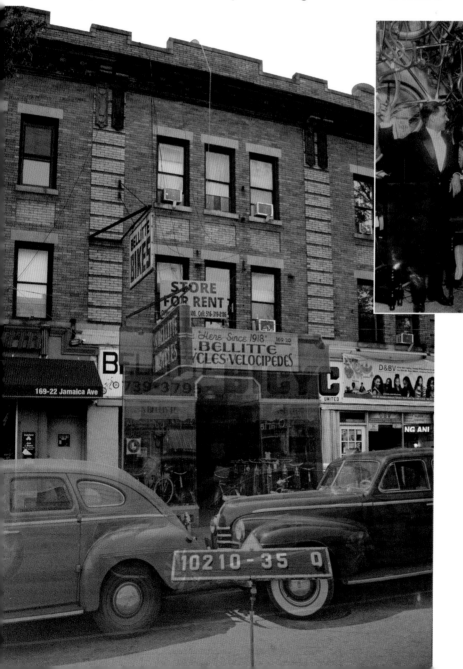

9415 Jamaica Avenue–Schmidt's Candy

Schmidt's Candy has been making and selling treats in Woodhaven since 1925. Current owner and head candy maker Margie Schmidt took over the business from her grandfather Frank, who lived upstairs with his wife and six children. The shop has always specialized in German candy using Old World techniques. Chocolates, hard candies, and marzipan are favorites. Most of the candy is made in the downstairs kitchen using Margie's grandfather's original tools. In fact, she is so respectful of tradition, she still follows his original recipes to the letter. Margie even goes so far as to close in the summer because the pure ingredients she uses do not fare well in the hot weather.

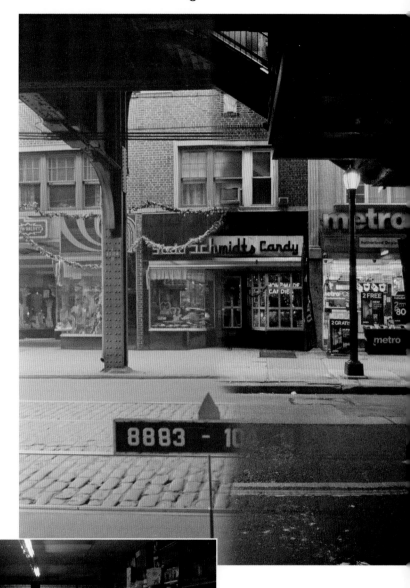

Staten Island

52 Barker Street

Like every New York City kid, this bunch obviously has one main purpose during the dog days of summer: keeping cool.

Incidentally, this neighborhood sits on the North Shore in Port Richmond, Staten Island close to the famed Staten Island Ferry. At one time, it was its own independent village.

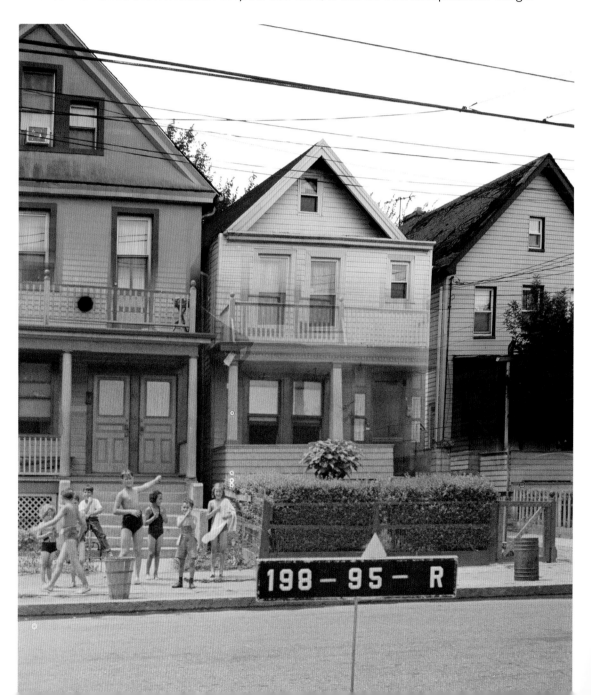

102 Delafield Place

Quite the pretty site, even today. Four lovely ladies sitting on the stoop of a well-manicured duplex in Port Richmond. Were they sisters? Neighborhood friends? Today, the place looks very much the same. Both residences have been kept up.

42 Reid Avenue–G. Caiozzo Candy Store

Current owners say this building in South Beach, Staten Island, has been modified several times over the decades. Notice the center roof line above the Royal Deli & Grill sign to see the original building. Also, note that the front wooden porch and gravel road have been replaced by a concrete sidewalk and street. The deli sits on a quiet residential avenue where there would seemingly be little business. However, just across the street is Public School 46, one of the largest in Staten Island.

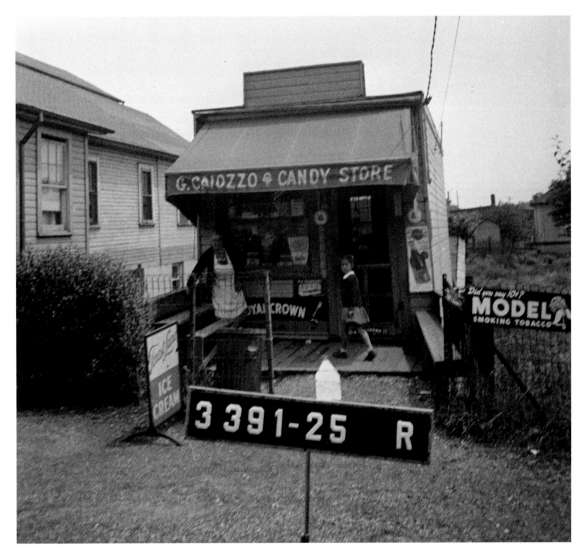

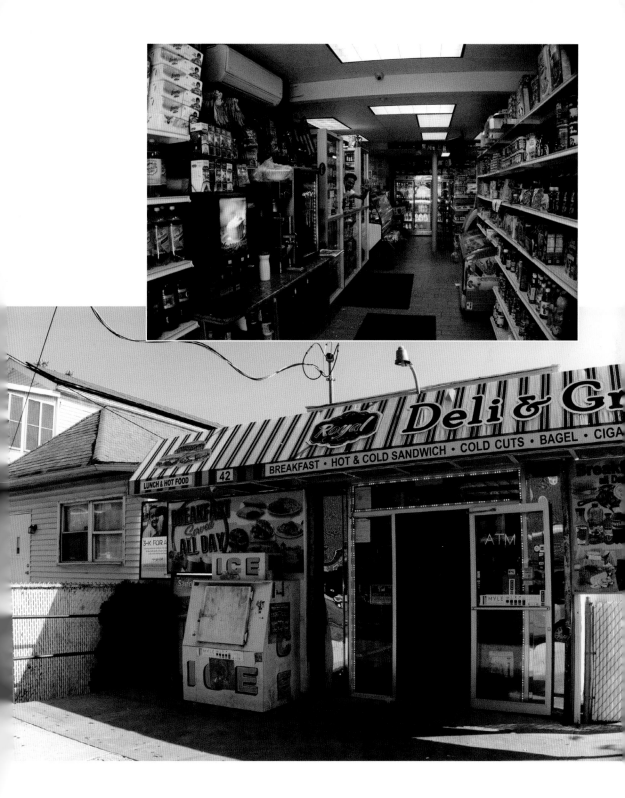

75 Saint Stephens Place

The neighborhood of New Dorp sits near the East Shore of Staten Island. Founded by the Dutch, it was one of the earliest settlements in all of New York City. In fact, *New Dorp* is Dutch for "New Village."

The girls in this photograph clearly have different things on their minds. One is corralling the young pups while the other keeps a cautious eye on the photographer.

292 Clifton Avenue

In the late 19th century, this northeastern part of the island was full of grand estates and mansions of some of the wealthiest people in America, including the Vanderbilt family . . . quite different from the boys sitting on the stoop in front of a seemingly empty lot.

Fast forward to now, and perhaps the only thing left from the photo is the telephone pole. During the 1960s and '70s, the neighborhood undertook yet another change as many middle-class family homes were built.

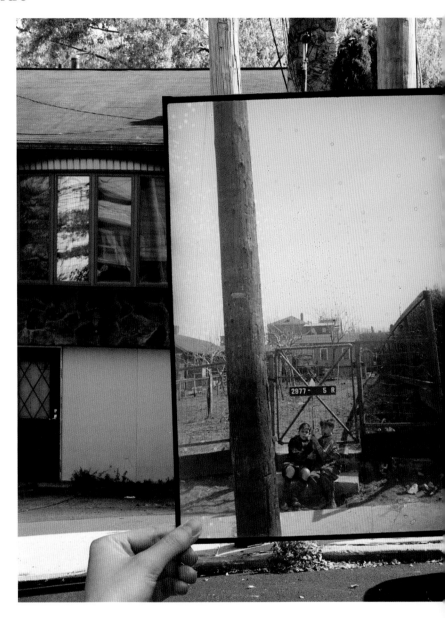

1005, 999, 997 Castleton Avenue

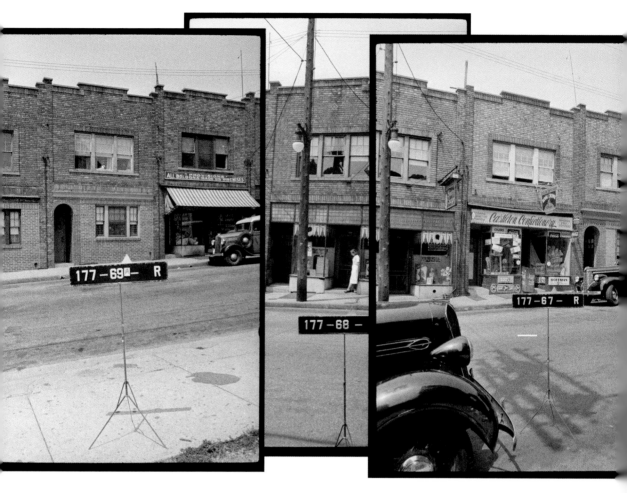

This strip of buildings in West Brighton, Staten Island, appears to have once been a bustling shopping spot, but not today. Quite intriguing is the young lady leaning against the display window of the beauty shop, deep in thought.

Start Your Own Search

Ready to browse the New York City Tax Photographs for yourself? Head to https://www.nyc.gov/site/records/about/municipal-archives.page. Please note: Researchers at the archives are also happy to help with locating errant photographs and answering general questions about the archive.

A few things to keep in mind: The website takes some time getting used to, for the numbering and category system of the tax photographs wasn't made for 21st-century web browsing. For decades, the photos were on microfiche reels meant to be used with a very different ordering system.

There is also a computer programmer and amateur genealogist Stephen P. Morse who took it upon himself to create a streamlined method of pulling up individual buildings from the archive. His website is https://stevemorse.org/vital/nyctaxphotos.html. Thanks, Steve!

Buying Prints or Digital Files

All the tax images on the municipal website are watermarked and are not at their highest resolution due to rights restrictions. You can purchase a hi-res image or even one printed on high-quality photographic paper by ordering directly from the Municipal Archives. There is a fee attached.

Photo Credits

Page 31: Jeremiah Moss
Page 37: Michael del Castillo
Page 71: Shubert Archive
Page 75: Daniel Krieger
Page 80: Wikimedia Commons
Page 108: Totonno family

About the Author

Jamie McDonald is an award-winning writer and filmmaker. His work has been seen on CBS, Fox News, PBS, and other networks. He is the author of four books and the creator of the Emmy Award–winning television series *New York Originals,* which has aired on more than 90 PBS stations across the country. His other TV specials include "American Originals: Made on Main Street," "A Tour of the Met," "America's Historic Homes: Timeless Design & Beauty," "Christmas in New York City," and "Christmas in New England."

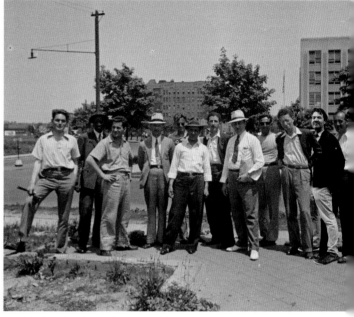

Author Jamie McDonald is pictured among several of the original tax photographers and clerks. If you know the identity of any of these men, please contact the NYC Municipal Archives at research@records.nyc.gov

His other books include *The Proper Bostonian's Guide to the Freedom Trail; New York Originals: A Guide to the City's Classic Shops and Mom-and-Pops;* and *No Access New York City: The City's Hidden Treasures, Haunts, and Forgotten Places.*

Jamie is also a former news producer at Fox News and production assistant at CBS. He began his television career as a CBS page on *Late Show with David Letterman.* While at CBS, he worked on various shows, including the *CBS Evening News, 60 Minutes,* and *CBS This Morning.* He still contributes to *CBS Sunday Morning* "Moments in Nature" segments, filming wildlife throughout America.

He is also the director of the 2006 award-winning documentary *Pulp Fiction Art: Cheap Thrills and Painted Nightmares.* Jamie grew up in Noblesville, Indiana, and has lived in New York City for more than 30 years. He is a graduate of Boston University and New York University.